FANTASY ART
EXPEDITION

FANTASY ART
EXPEDITION

DRAW AND PAINT FANTASTIC CREATURES AND CHARACTERS

WRITTEN AND ILLUSTRATED BY FINLAY COWAN
ASSISTED BY CHIARA GIULIANINI

IMPACT

FOR ALL MY GHOSTS...
...AND MY GUARDIAN ANGELS.
Finlay Cowan, 2010

Endpapers: 'Gasoline' design by Storm Thorgerson
and Finlay Cowan for 'The Catherine Wheel'.
Photography by Rupert Truman.
Art Direction by Sam Brooks. Reproduced by kind permission.

A DAVID & CHARLES BOOK

Copyright © David & Charles Limited 2010

David & Charles is an F+W Media Inc. company
4700 East Galbraith Road
Cincinnati, OH 45236

First published in the UK and US in 2010
Text and illustrations copyright © Finlay Cowan 2010

ISBN-13: 978-1-44030-387-6 paperback
ISBN-10: 1-44030-387-8 paperback

Printed in China by RR Donnelley
for David & Charles
Brunel House, Newton Abbot, Devon

Senior Commissioning Editor: Freya Dangerfield
Assistant Editor: James Brooks
Copy Editor: Lin Clements
Senior Designer: Jodie Lystor
Production Controller: Kelly Smith
Indexer: Lisa Footitt

David & Charles publish high quality books on a wide range of subjects.
For more great book ideas visit: www.rubooks.co.uk

CONTENTS

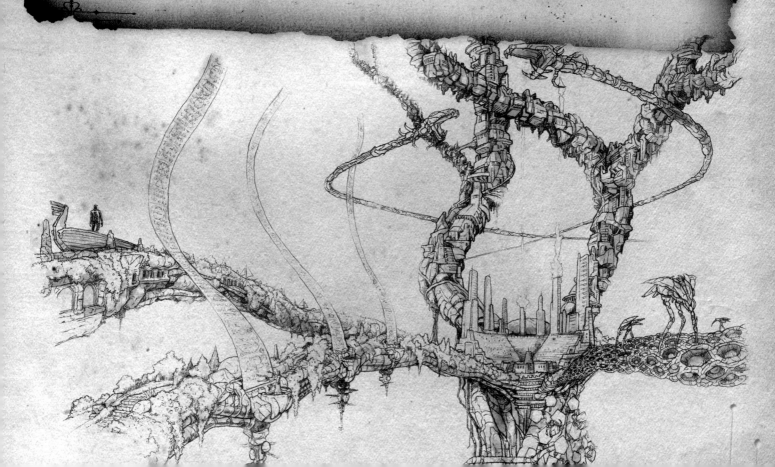

INTRODUCTION

Our world is abundantly rich in magical creatures, mythical monsters and spirit beings. Since the dawn of time humans have glimpsed beyond what is real, seen the impossible and told others of their amazing experience. Mankind continues to search for these hidden mysteries irrespective of how technologically advanced we become. Everybody has a story to tell about the unknown and in this book we will look at just a few of the key geographical locations where fantasy crosses over to reality, and where artists can find incredible beasts and beings to inspire their work.

Stories of fantasy creatures, such as vampires, werewolves, fairies, dragons, zombies, water spirits and a myriad of others, are more than just entertainment – they are the ancient crucible of all human culture. Before the industrialization of storytelling through print and film there was only the spoken word, spreading stories like migratory birds along the trade routes of the ancient world. To the Greeks, satyrs, fauns, centaurs and spirits were all as much a part of the real world as giraffes and hippopotami. The motifs and themes that we see endlessly repeated across the globe are direct from the birthplace of the human imagination.

In the modern world our fascination with the supernatural has reached an historical high. Despite the depredations of the mechanized world, the global media juggernaut of film and computer games has proved to be the perfect vehicle for the ongoing survival of the ancient stories, and all around the world the future rings with the sounds of tales of magic and mystery being re-told and re-imagined.

HOW TO USE THIS BOOK

• **Expedition Goals** – In this book we travel the world on an expedition in search of famous sites of supernatural and mythological interest and learn how to draw and paint some of the inhabitants from these places. You will find a wealth of helpful material on drawing and designing your characters, developing your ideas and finding inspiration.

• **Projects** – Each of the 12 geographical locations features a distinctive fantasy character and a detailed step-by-step project showing how it can be rendered by artists using any traditional or digital media. A large-scale painting at the start of each chapter places the project in context and shows how the creatures you draw and paint might be incorporated into a larger image.

• **Techniques** – The techniques are deliberately simple so it should be easy to use them with any media. The idea is that you should be quite mobile, researching stories and getting inspiration from the world around you. Remember, this a worldwide expedition, so try to get out there and work on the move!

• **Journey Time** – Each step-by-step project has an estimated time frame for producing the art. In keeping with the simplicity and ease of each exercise, it should be possible to obtain results quite quickly and the techniques and equipment used are based on that intention. The short exercises are intended to build confidence and help you produce great fantasy art.

• **Equipment** – The projects can be carried out with the minimum of equipment. You won't be expected to spend money on expensive canvas and huge sets of oil colours. Some exercises require a computer and a basic understanding of Photoshop, but these are only used for colouring and you will never need anything more than a pencil and paper to create your character.

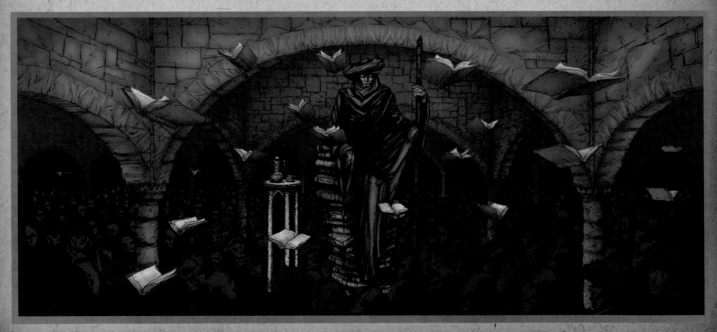

Research and Inspiration

The world of myth, fairytale, folklore and the supernatural is seemingly infinite. Attempting to learn all there is to learn of this immense subject makes one feel like the young hero or heroine who enters the enchanted forest – the further they travel, the larger the forest seems to be and the thicker the trees become. I scrambled for years through this dense territory, picking up stories as I went, and after years of wading through the chaos, patterns and connections began to emerge.

Just as the athlete must repeatedly perform the same exercises to train their muscles, or the craftsperson must carry out the same tasks to master their particular skill, so must a storyteller immerse themselves time and again into the great ocean of stories in order to train their imagination until the art of myth becomes part of their muscle memory. Gradually, the themes and motifs of fantasy become part of their being and they begin to see the interconnectedness of the world in which they operate. The immense global repository of fantasy tales is evidence, not of what is 'out there', but of what is inside us.

When searching for ideas and inspiration, be prepared to pursue what interests you, take notice of the things that grab your attention and pursue them further. Follow leads, search out more information; some may be dead ends but other hunches will pay off and ignite your imagination. Read – a lot. Treat your creativity as though it were a garden that needs to be nurtured. Give it time to grow – you have a lifetime to get good at this.

NATURAL WORLD AND MAN-MADE WORLD – Fantasy artists create their own world but it is necessary to draw inspiration and ideas from the world around you. The natural world in particular has a great influence on fantasy artists, so research and going on your own expeditions to visit areas of natural

beauty will give you ideas and inspire you. Likewise, the man-made world is full of cool stuff, past and present, which will flow into your work. Much fantasy art takes its content from Medieval European and Celtic design but any period of history can serve to inform and inspire. A good grounding in the techniques of perspective will make it much easier to replicate this material and will also affect the way you look at things.

SECONDARY SOURCES – I can't stress the importance of using libraries and the Internet for research. The main rule is to use other fantasy art as a source of *inspiration* but use original resources for *information*. It is important to evolve your own ideas for your fantasy worlds, so copying other fantasy art is a waste of time – only by studying history, geography, science, technology, architecture, design and art will you be able to develop your own ideas and be original.

MENTORS AND TEACHERS – Never forget the importance of finding teachers and mentors: these people are the 'living libraries' who can advise, inspire, educate and show you how to progress. They could be other artists, family, friends or people in educational institutions. Always ask people for advice as most are keen to help when they learn what you are trying to achieve.

Drawing

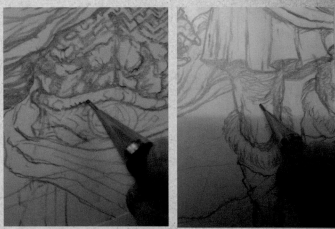

Observation and Sketching

Many artists feel overwhelmed when they begin, as it seems there are so many areas to cover and so many skills to be learned – anatomy, perspective, the natural world, animals, clothes, jewellery and hair – and then there are drawing, painting, digital art and a dozen other skills to be acquired. Where do you begin? The answer is simple: start off by doing a little of everything. Be disciplined, set aside time each day or week to cover a certain essential area such as anatomy or perspective, and then set aside a separate time to explore media and software. You will find that each area influences the others, so as time goes by it will become much easier and quicker.

Before you begin a new artwork first immerse yourself in research to inspire and inform you and then do some preparatory sketches. These can either be simple doodles or complex studies, where you will encounter all the major difficulties that the proposed artwork might present before committing to the final piece.

Although computers have become invaluable in all fantasy art industries, it is impossible to create fantasy art without good drawing skills and a solid grounding in pencil drawing is essential in any creative industry. So observe and draw … keep drawing, and then draw some more and never, ever stop. Carry a sketchbook with you at all times and, if you forget it, draw on napkins and used envelopes. Observe and draw until your pencil becomes a sixth finger – it's the only way.

Research takes time, inspiration requires dedication and art requires skills that can only be learned with patience and practice. It would be impossible for one book to teach you everything you need to know to create fantasy art masterpieces but here are a few very basic techniques that will be useful to learn. Drawing is a fundamental and crucial skill that all fantasy artists must learn. Detailed advice on how to render images in pencil is given in the project chapters, so this section will recap the key skills of observation, sketching, line work and shading and provide succinct advice on anatomy, the knowledge of which is crucial when drawing fantasy characters.

Line Work

You will often hear artists and art lovers speak about the beauty of the line. Every artist has their own 'line' that is unique to them and makes their work instantly recognizable when compared to anyone else's, so line work really lies very much at the heart of an artist's work and style.

Japanese artists would meditate for hours before expressing an idea in a few short strokes and many artists feel they never need to use shade or paint or any other medium or technique to work, such is the importance of the line. Your line is like your signature and will develop and evolve as you progress – how you develop your line is a matter of personal choice. For example, I only ever use one type of pencil – a self-propelling technical pencil that offers a consistent line with very little width variation. This is rare for a fantasy artist but more common for graphic artists or comic artists as it leads to a very 'clean' sharp look and is excellent for very detailed drawings. Hergé, the creator of Tintin, spawned a whole genre based on this technique called *la ligne claire* or 'the clear line'. However, you may wish to use a normal softer pencil (2B–9B), which many artists feel is more organic and better able to physically express their hand movements as they draw.

Shading

You can find whole books dedicated to shading, particularly when it comes to inking, but here are a few basic tips to ensure success:
• Have a mirror and light beside your drawing board so you can use yourself as a model to see how shadow falls on your face, hands and so on when you move the light source around.

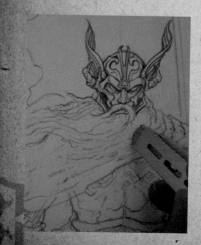

• When using shadow it is important to think in terms of light: with pencil work you can use a fine eraser to break up the shadow areas to add highlights or work 'out of black', which means covering a larger area with dark pencil then erasing all the light areas from it.

• When using pencils, pastels or coloured pencils you can take two approaches: you can build up soft tone with soft pencils (2B–9B), which produces solid areas of shadow, or you can use a harder pencil (HB–7H) to build up shadow areas with lines, cross hatching and other techniques such as stippling, which is a mass of tiny dots.

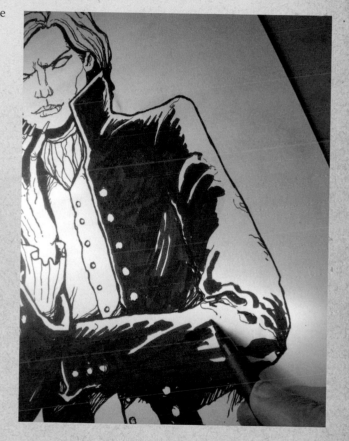

• When working with ink you can really focus on shadow (the comic artist Frank Miller's work is a great example of this) and you can use white paint to cover mistakes or add light areas. When using brushes to ink in your work there is an enormous variety of techniques you can use, from line work to stippling, and it can take considerable practice to master brush work techniques in ink – simply because you can't easily go back and erase mistakes!

• Shading with paint becomes far more complex and is much more about the balance between light and shade across the whole image and how you build up shadow and light with successive layers of paint. You will see that the painting exercises in this book focus on simple ways to do this.

Basic Anatomy

Although many fantasy art characters require a great deal of exaggeration in the way they look, it is essential to learn how to draw accurate human figures. You can begin by working with standard anatomy books for the artist but it is advisable to attend some life drawing classes. It is also invaluable to draw from life. It may not seem relevant when you want to draw diaphanous goddesses or demon hordes but the skills acquired from observing and drawing real humans in real situations will benefit any artist enormously. There are a great many skills to be learned, and you could devote a lifetime to just mastering anatomy let alone anything else, but it costs nothing to take a sketchbook and sit in a public place drawing what you see around you.

Proportion

The head is often used as the unit of size for proportioning the rest of the body. As a general rule, the body is equal to 7½ head lengths but the drawings below left show it in units of 8. To get the body proportions correct, begin by drawing stick figures, as shown below.

STICK FIGURE – AIM FOR FLOW AND BALANCE

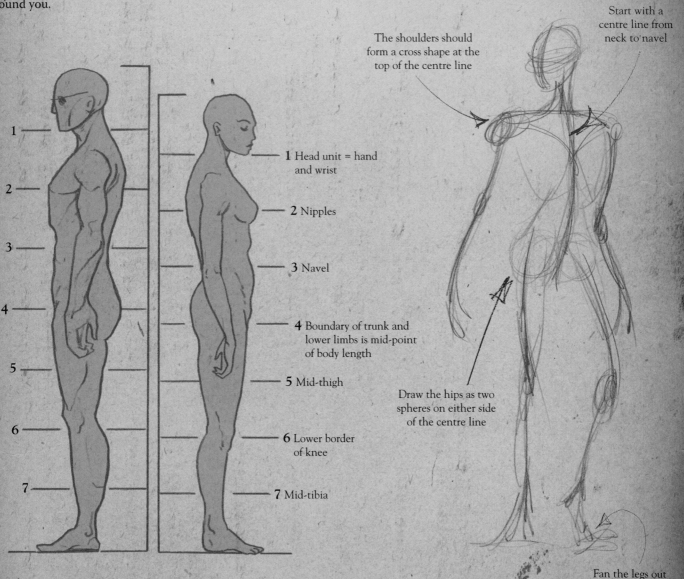

1
2
3
4
5
6
7

1 Head unit = hand and wrist

2 Nipples

3 Navel

4 Boundary of trunk and lower limbs is mid-point of body length

5 Mid-thigh

6 Lower border of knee

7 Mid-tibia

The shoulders should form a cross shape at the top of the centre line

Start with a centre line from neck to navel

Draw the hips as two spheres on either side of the centre line

Fan the legs out at the bottom to provide a solid base for the feet

MUSCULATURE

Bones are moved by muscles, which come in various shapes and sizes. As a rule, long muscles move the limbs and broad muscles move the trunk. The sketches here show the basic form of the male and female musculature.

After producing a rough drawing I use a light box to do a clean line version. I trace off different elements (figures, sky, foreground, background) on separate sheets of paper which are then scanned and put back together in the computer. It is then easier to select the separate elements and add different treatments to them, such as filters and layer effects, without having to cut them out using selection tools.

BASIC MALE MUSCULATURE

Create the basic drawing as a series of curves, which roughly follow the lines of the muscles

Fantasy figures tend to have more muscles, which are bigger and more stylized

Work fast and build up the shape and weight with rough lines

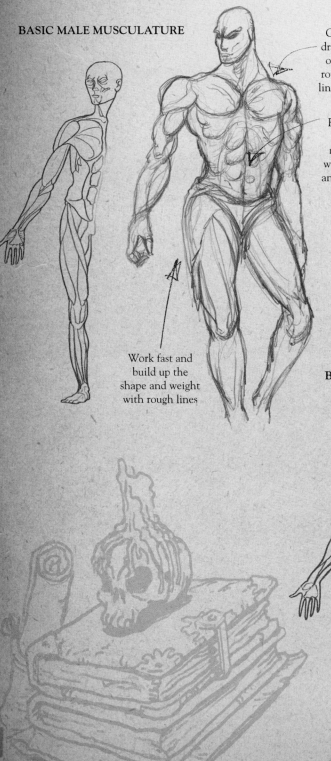

BASIC FEMALE MUSCULATURE

For a female make the neck slightly longer than a male

Make the waist slimmer and the hips wider

Smooth out the muscles

Make hands a little longer and fingers finer

Colouring

Artists have a wide range of materials to choose from but one of the goals of this book is to show you how to produce good fantasy art with inexpensive materials. Of course there are some things you shouldn't skimp on, such as good brushes and reliable computers and software. This section looks at the basic colouring options that you can apply to your drawing. The 12 step-by-step projects that follow also show in detail how to colour images using watercolours, inks, acrylics or gouaches, or using digital software.

Colouring Materials

You won't need expensive paints and canvas for the exercises. You will need some portable materials though, as follows.

WATERCOLOUR BRUSHES – You can't skimp on brushes so don't buy cheap. You will only need three at most – thin, medium and thick. Watercolour brushes are much softer than other paint brushes but you can use them for both if you make sure you clean them carefully after every use and store them away properly.

WATERCOLOURS – You can get by with a simple set of portable watercolours to begin with. You can then advance to more expensive colours such as Schminke, which have more intense colours and mix beautifully on the paper surface.

PAINT BRUSHES – You'll only need three (two fine ones and a thicker one) for gouache or acrylic work and could just use your watercolour brushes. Don't use acrylic or oil brushes for watercolour work as they tend to be too stiff. A flat-ended brush is useful for working paint up to line edges.

PAINT – Begin with acrylics or gouache, which are cheap and easy to use, and then advance to oils if you find this the medium you prefer. Have plenty of white, whatever medium you use.

INK BRUSHES – You may want to use ink brushes occasionally. You could use your thinnest watercolour brush for ink.

INK PENS – The exercises in this book only require the use of disposable technical pens, available from any good art shop.

PENCILS – Any pencil will do. I use self-propelling technical pencils with a 0.9mm thickness and B leads for a consistent line, but normal pencils allow great variation in line thickness.

COLOURED PENCILS – There are various makes available and it's a matter of personal choice as to which you prefer.

DRAWING PAPER – Any kind of drawing paper will do but it's good to have a choice of two types: cartridge paper with a rough surface for tonal work and smooth paper for line work.

PAINT SURFACES – The two painting exercises use Bristol board (a type of heavy art board) and art board (a stiff card with a hard surface that has the grain of canvas but is much cheaper). I've used 180gsm (80lbs) weight but you could use heavier if you prefer.

WATERCOLOUR PAPER – You'll need a few sheets of any type of watercolour paper. Watercolour paper is designed to absorb the water nicely so you can't use anything else for watercolours.

INK DRAWING – You can use the same Bristol board that you use for painting, mentioned above. It is smooth and holds black ink well without it bleeding.

Finlay's Equipment

- 0.9mm self-propelling technical pencil with B lead
- Any paper he can get his hands on
- Watercolour paper (Fabriano or Arche)
- Sketchbook (Aspinall)
- Light box made for him by his Dad
- Propelling erasers (Muji)
- Pitt Artists black ink pens (Faber Castell)
- Watercolours (Schminke)
- Computer – Macintosh G4 Powerbook (laptop), DVD superdrive and a 17in (43cm) screen
- 1 terrabyte (approx.) of external hard drives for backing up
- Adobe Photoshop
- A4 graphics tablet and stylus (Wacom)
- A4 flatbed scanner (Epson)

COLOURING WITH WATERCOLOURS

Watercolours are ideal for working quickly and for trying out colour schemes before committing yourself to acrylic painting or digital work. When using watercolour, start with a small amount of water in a palette and mix in colour until the preferred consistency is achieved. This ranges from very light colours with a lot of water to very intense colours with less water and more paint. Apply the paint to the paper using a soft brush and add further colours while it is still wet, which causes the pigments to run together and create a dazzling

variety of tones and effects. Inks can also be added to the wet colours to create further patterns and effects.

Watercolours are also good for creating textures. HP (hot-pressed) and Rough watercolour papers have different surfaces, allowing you to create interesting blends. Tissue paper, sponge or even twigs and leaves can be dabbed on to the surface while the paint is still wet to create unusual patterns. Salt can also be sprinkled on wet colour to create other effects.

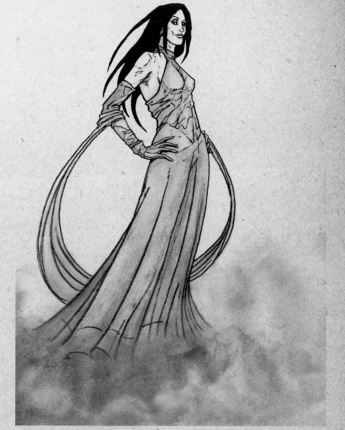

COLOURING WITH ACRYLICS AND GOUACHE

Many artists prefer acrylics and gouache to watercolours as they take longer to dry and allow more control. The outcome is very different, however, so there is little in the media to compare. Acrylics and gouaches are cheap, water-based alternatives to oils, which take even longer to dry, so most artists begin with acrylics to learn the techniques.

Like any medium, paints can take a lifetime to master but early results can be achieved by following some simple rules, which are outlined in some of the exercises in this book. These consist of the basic mixing and building up of colours on the surface, and the addition of shadow and highlights.

Paints and inks can be used together to create interesting effects, such as the werewolf on page 57, although the paint needs to dry completely before inking is started. Using ink alone can also result in strong, illustrative images – see the vampire on page 47.

Mixing Paint

Mixing paint is almost an art in itself. For the base colour begin with two colours, together with white. Beginners should mix the paint thoroughly to ensure an even colour throughout. As you progress you will learn how to mix colours on the canvas itself but this isn't recommended on Bristol board.

Mix a variety of shades well, so there is no variation in the colour. The idea is to mix several tones before settling on the one you will use for the base colour and the strong lines. Take time to mix several small amounts of colours to test them first.

Before you begin painting you must paint a series of colour tests on paper or card of the same type you will be working on. Paint always dries to a different colour so wait and see how it look when dry. Use these tests to check the correct consistency of the mix.

COLOURING WITH COLOURED PENCILS

Coloured pencils are popular with fairy artists and children's book illustrators and can be easy to use but difficult to master, like most media. They allow great scope for depth of colour and a wide variety of textures, which are created using different combinations of strokes. Detailed areas of tone are built up using several colours that are overlaid. They are used in much the same way as normal pencils, with different effects being achieved by pressing harder or softer, or using the pencil in varying ways to achieve a range of strokes.

DIGITAL WORK

You could devote several hundred pages to Photoshop and 3D modelling packages so it's impossible to decribe here in detail how to design and paint with computers. However, there are some simple techniques described in this book that will help to show how it's done. Here are some basic rules when working with computers:

- When buying a computer, get the best you can afford.
- When buying software, take your time and find out in detail what you really want before jumping in. Don't bother getting lots of software you don't need – it will just use up time better spent practising your art. It is better to learn one software package and be good at it than to be just average at a lot.
- Computers aren't creative – you are! Don't be fooled by the ads, computers won't make you more capable or better at doing anything at all. In fact, they are more likely to slow you down and make you imaginative. Artworks that are computer driven using pasted textures and effects look tacky, cheap and dull. It takes real creativity and imagination to lift a digital image into something special that will capture people's hearts and inspire them.

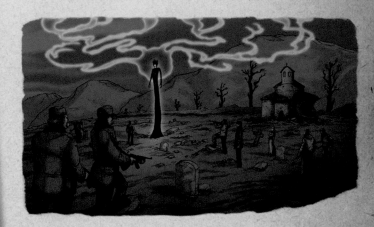

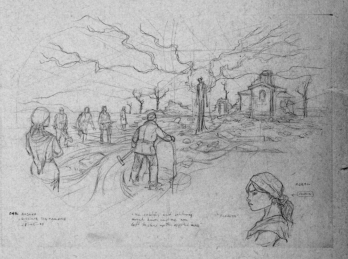

14

SPECIAL EFFECTS

There are many glamorous and interesting effects in most design software packages that can be executed at the touch of a button. The drawback is that these effects can be overused or employed to cover up bad drawing. Relying on software effects to patch up artwork inconsistencies often leads to more problems so always try to get your drawing right at the pencil stage, thinking ahead to which effects you will be using. A few examples of worthwhile effects are shown below.

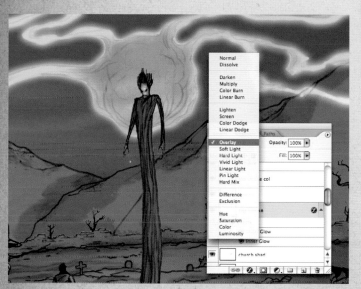

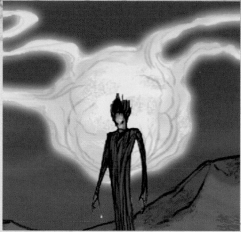

GLOWS – In this case both Outer Glow and Inner Glow have been used to give the halo around the vampire a luminous aura.

FILTER MENU – The Filter menu (found along the top of the Photoshop screen, not on the palettes) has a huge range of filters that you can experiment with. Always use such computerized effects sparingly as they can make an image look tacky. There are also a great many Blur options in the pull-down menu. For the smoke effect here there was a pencil layer, a colour layer and a shadow layer, all of which had a variety of effects applied to them to create the overall effect.

LAYER PROPERTIES – The top of the Layers palette in Photoshop has a button with a pull-down list that affects the way the chosen layer responds to the layers around it. The most common use of this in this book is Multiply which makes your layer see-through, but you will find many other interesting effects on the list. Set the layer mode to Overlay to make a smoke effect that will be transparent. When using light colours Multiply won't work as it disappears against the background so experiment with Overlay or Screen mode. This usually changes the colour of the smoke so re-adjust it to suit your tastes using the Hue/Saturation dialog box.

SAMPLING TEXTURES

A great way of adding tone and texture to an illustration is by sampling textures from photos, objects or illustrations. A photo of a cloudy sky can be used to create fire or a scan of an old notebook page can provide a mountain texture. These textures can be colourized and manipulated by hand to fit the background in question and it is worth building up a library of scans for this use. It's always best to make your own textures from photos or rubbings or just by experimenting with pencils and paints; these will build up over time until you have your own unique collection of textures. Using textures downloaded from websites is boring and unoriginal and they tend to look rubbish unless you manipulate them by hand first.

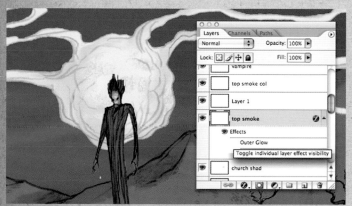

You can see here how a simple texture gave more form to the graveyard in this image.

LAYER STYLES – Another menu of effects can be found at the bottom of the Layers palette in Photoshop and includes effects for Bevel and Emboss, Drop Shadows, Inner Glow and several others. Just select your layer then choose your effect and adjust the settings in the dialog box that comes up.

Here a similar texture was used for the beginnings of the mountains. Compare this with the final image and you can see how it works when it is overlaid on to pencils and other colours.

A WORLD OF INCREDIBLE BEASTS AND BEINGS ...

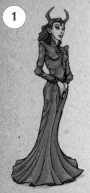

1

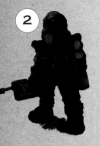

3

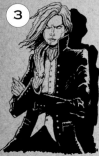

5

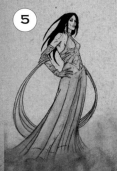

4

Map Key

● Location of creatures featured in the step-by-step exercises

● Location of fantasy creatures illustrated throughout the book

○ Location of other fantasy creatures described during the expedition

NORTH AMERICA

SOUTH AMERICA

This book is a whistle-stop fantasy art tour of just some of the countless locations where incredible beasts and beings can be found. The world map shown here reveals where some of these creatures are located and the projects within the book show you how to draw them when you find them. During our expedition you will also learn about scores of other creatures from all over the world that will inspire you as a fantasy artist.

On our fantasy art expedition we will journey to the ancient fairy courts of Ireland, delve deep into German folklore to discover dwarves, and trek through the wild mountains of Bulgaria and Kosovo where werewolves and vampires hunt. In Scandinavia we will discover nightmare females and the Wild Hunt, and on our journey to England and Scotland encounter dragons and screaming female spirits. We visit the sand-blasted regions of Egypt where the djinn is king, barely escape the dreaded vampire hoards of Africa, and wander lost highways of the USA where ghost spirits congregate. Come, the expedition is about to start ...

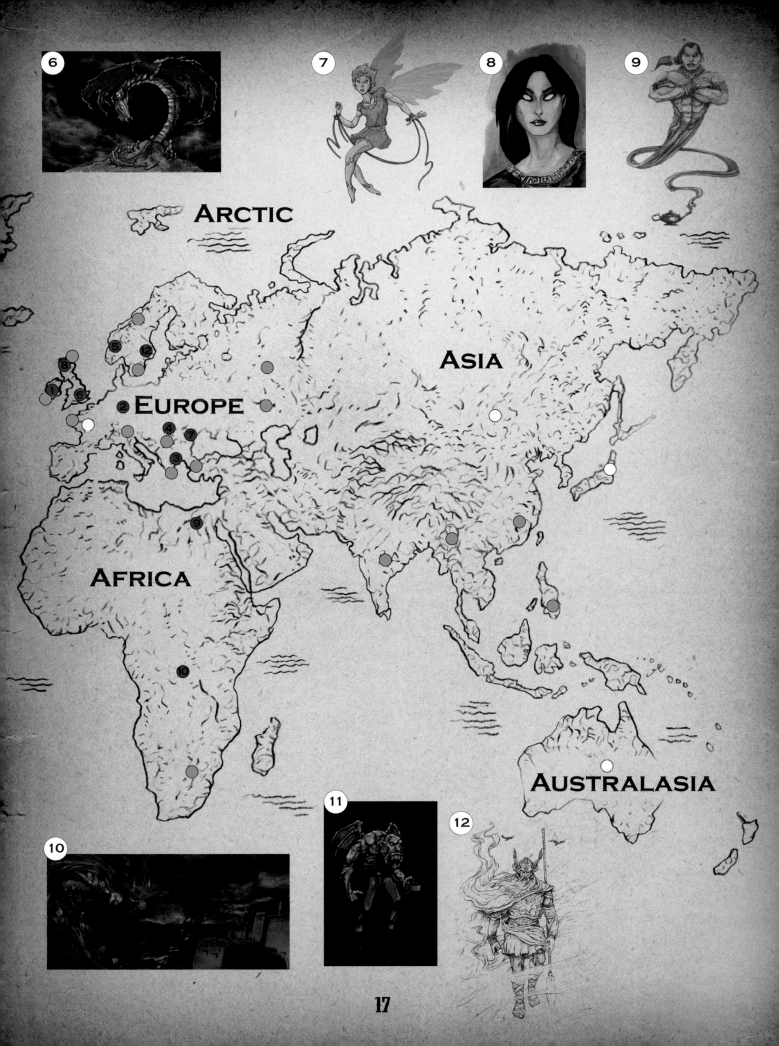

ARCTIC

ASIA

EUROPE

AFRICA

AUSTRALASIA

THE TUATHA DE DANNAN

The Celtic arc, consisting of northern France (Brittany), Wales, Ireland and Scotland, has for centuries been a stronghold of fairy folk and it is in these regions that you will find a high incidence of supernatural beings and stories about the Tuatha De Dannan.

The Tuatha De Dannan are said to be the aristocracy of the fairy peoples from which all elves and fairies are descended. Their court lies beneath the Hill of Tara in County Meath, Ireland, which according to tradition was the seat of the High Kings of Ireland. The area contains a number of ancient monuments.

In Irish mythology Flidais appears as a goddess of the Tuatha De Dannan and was the wife of King Adamair. She was a shapeshifter and wood spirit, protector of the forest and animals, and drove a chariot pulled by deer.

NORTHERN IRELAND

HILL OF TARA

REPUBLIC OF IRELAND

EXPEDITION LOCATION: Ireland is our first destination on this expedition, a country with a vibrant tradition of folk tales derived from its strong Celtic roots, as well as from the waves of migrants who have settled there over the centuries. Irish traditions can be traced back to countries worldwide, from France to India.

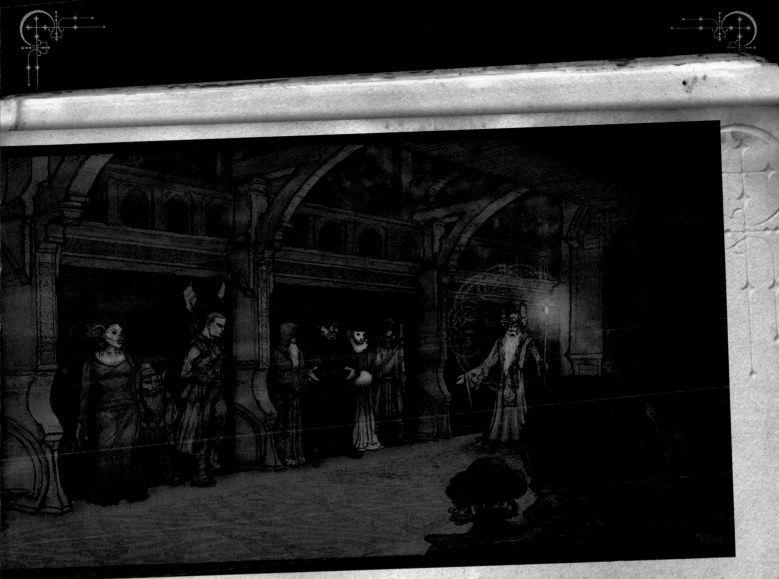

 The goddess Flidais is seen here in royal purple, with other members of the fairy aristocracy, attending court presided over by Finvarr, lord of the Tuatha. The stepped sequence overleaf shows in detail how to render Flidais. I depicted Flidais as poised and elegant but with a slightly alien cast to her features so she does not appear too human.

EXPEDITION PREPARATION

• TRAVEL GOALS:

Learn how to draw a wood goddess from Irish mythology (a useful skill for any aspiring fantasy artist)

Discover how to produce the quickest, simplest kind of colour visual in Photoshop

• JOURNEY TIME:

About one hour on pencils, 30 minutes in Photoshop

• EQUIPMENT:

Fine pencil and eraser
Cartridge paper – 180gsm (80lbs)
Computer, scanner and Photoshop or Painter software

Expedition Discoveries

Poet and author W.B. Yeats divided fairies into two types – trooping fairies and solitary fairies. Trooping fairies were the aristocratic families such as the Tylwyth Teg and the Daoine Sidh, who were descended from the Tuatha, while solitary fairies included leprechauns and brownies. The trooping fairies belonged to the Seelie Court, while all malevolent creatures belonged to the Unseelie Court. On your journey you may be lucky (or unlucky) enough to encounter some of these characters.

The Seelie Court

Members of the Seelie Court, some of which are shown below, are usually seen around twilight in long, solemn processions and are known to seek help from humans.

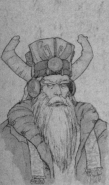

FINVARR – Finvarr is the most famous of all the kings of the Tuatha. He was a great womanizer who chose many lovers from the human realm. He was also known to be a great chess player.

TYLWYTH TEG – Tylwyth Teg is a common Welsh term for fairies, which means 'the fair folk'. It is said that they are ruled by Gwyn ap Nudd, the god of the underworld, and that they live around lake Llyn y Fan Fach in south Wales. These fairies are neither entirely good nor completely evil. People tidied their fires before going to bed to make these fairy folk feel comfortable. Other Welsh fairy families include the Gwragedd Annwn, the Plant Rhys Dwfen and the Bendith Y Mamau.

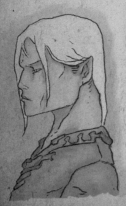

LJÓSÁLFAR – The other major branch of fairy society is the tall and fair Scandinavian elves, who are closely related to the Seelie Court. The Norse Ljósálfar, or 'light elves', are ruled by the god Frey from a palace in Alfheim. Their name was said to come from the Latin *albus* meaning white, suggesting their purity. The same word was given to the snow-covered Alps and to Albion, the old name for England, allegedly because of the white cliffs of Dover.

The Unseelie Court

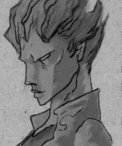

The Unseelie Court of dark elves is the evil opposition to the Seelie Court. It is also known as the Host of the Unforgiven Dead or the Sloagh and takes in every type of nasty demon, goblin and ghost in Celtic myth. As many fairies and elves are neither good nor evil it is hard for the Tuatha to know their allies. Those described below are likely to be against the Seelie Court, and humans.

FUATH – The Scottish use the name Fuath to refer to water spirits who inhabit the seas, rivers and lochs, or sometimes to highland or nature spirits. Either way all Fuath are evil. Their appearance varies – they may be covered in shaggy, yellow fur or just have a mane down their back. They may also have webbed toes, tails with spikes and no nose. They can look vaguely humanoid or completely demonic. Sometimes Fuath intermarry with humans, producing mutated children. Like most of the Unseelie, they fear sunlight and steel, both of which kill them instantly.

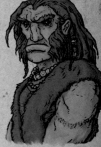

TROLLS – Trolls can be found throughout Scandinavia but are also said to live in a far northern land called Trollebotten, the idea of which seems to coincide with the Old Norse Jötunheimr. Trolls live in family groups, are said to be exceedingly ugly and have a penchant for jewellery and treasure, which they often steal from humans. Haugtroll (mound trolls) or Bergtroll (mountain trolls), are trolls who live underground and are often mistaken for dwarves. Trolls are not specifically allied to the Unseelie, but are more likely to take the side of evil than good.

SVARTÁLFAR – In Norse mythology, Svartálfar, or 'Swart-elves', are subterranean creatures who dwell in the world of Svartálfheim. The original Svartálfar worked the forges on the lowest level of the world tree of Norse mythology and are often compared to the dark elves called Dökkálfar. Svartálfar are a malicious race constantly at war with the Seelie Court.

PENCIL WORK

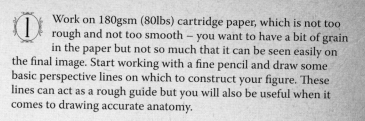

① Work on 180gsm (80lbs) cartridge paper, which is not too rough and not too smooth – you want to have a bit of grain in the paper but not so much that it can be seen easily on the final image. Start working with a fine pencil and draw some basic perspective lines on which to construct your figure. These lines can act as a rough guide but you will also be useful when it comes to drawing accurate anatomy.

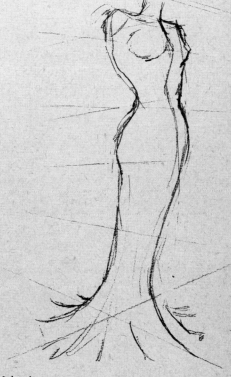

② Make the centre line an elegant, curving shape to help delineate the body stance – in this case the back is arched. To this basic pose, add a very slim waist and a long flowing dress. Splay the dress out at the bottom using the basic perspective lines to determine the proportions.

③ Draw a long, elegant neck with the head held high. Make it quite thin so that it appears less human and more elf-like. Always try to work rough and loose in the early stages of a drawing. There is a tendency to get straight into accurate detail but this can cause problems later on. Here, only the most rudimentary shapes for the features and limbs are sketched in so that the image can be viewed as a whole and mistakes can be seen more clearly.

Facial features and hair

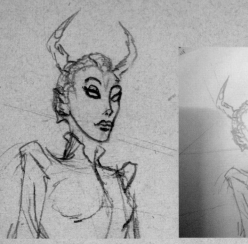

4 Now start to develop the features. Use an eraser to remove your construction lines. Allow your rough outline to remain visible and work on top of it to refine the features. You will find more detailed instruction on drawing a beautiful goddess on pages 58–69, so refer to that too if necessary.

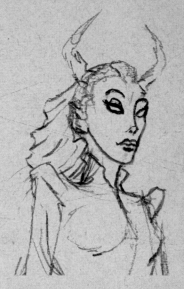

5 Add the hair next and, in the case of Flidais, this should be thick and wavy. Begin with some lines sweeping out from the back of the head, followed by a curvy line bounding them.

6 The body shape of this goddess is very tall and slim, but the dress isn't long enough so lengthen the whole bottom half of the figure before spending any time working on essential details. You are still working roughly so check you are happy with the length and shape of the dress and then start to work on the detail, particularly the way the dress forms a semicircle of folds at the base.

Tightening up

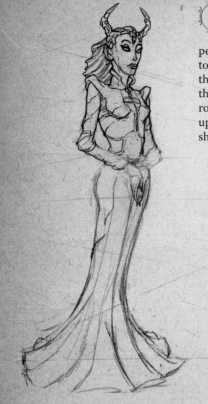

7 Now it's time to move on to the second stage of pencilling, from 'roughs' to 'tightening'. Work from the top of the image to the bottom erasing the rough marks and building up details with harder, sharper lines.

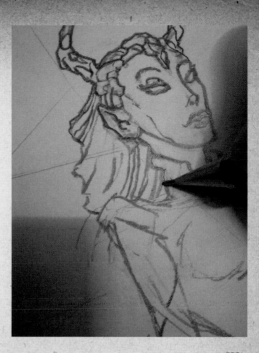

8 You can see here how to work into soft, thick lines with hard, sharp lines. It is not always necessary to erase the rough lines – you can leave them on areas with heavy shadow and outlines of clothes. Generally, use the eraser more on 'clean' areas such as faces and hands or detailed areas of clothes and jewellery.

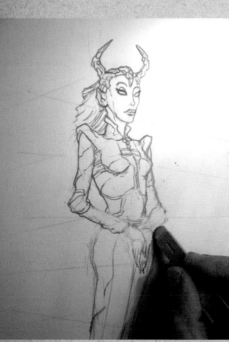

9 During the tightening up stage, get to grips with the fine detail of hands and other important features and correct any major mistakes. This part of the process requires going over and over each line, and you have to be prepared to erase and re-draw a finger or hand dozens of times until you get it right. As you progress this will take less and less time until you can get it right pretty much first time, every time.

10 The final pencil image can now be cleaned up. In this case it is not necessary to do a trace off with a clean line as you want the final image to be not too loose and not too tight for digital colouring. Leaving a lot of the loose pencil lines and marks in your original drawing can add texture to the final image. Some artists prefer to keep their artwork very clean and crisp, but it's a matter of personal choice.

Digital colouring

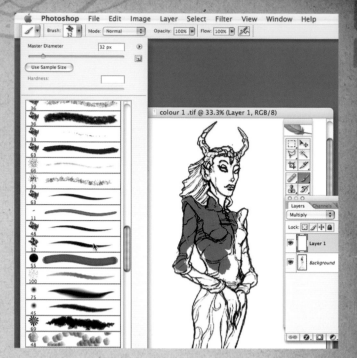

This quick technique for colouring is used for the kind of visuals created by production artists in the film industry. It doesn't aim for hyper-real perfection of the painterly approach but still needs to show volume, tone and depth without spending days or weeks achieving it. Scan your cleaned-up pencil drawing and set it as a new Multiply layer in Photoshop. Using the Brush tool, paint a basic colour layer – choose a light purple for the dress, pinky-mauve for the headdress and pale grey for the face and hands. There are thousands of brushes to choose from in Photoshop and you can download thousands more free from the Internet. You will eventually find a small selection that you like and always return to.

(11)

By this stage you should have an image with basic flat colour. Notice that there is little colour variation in the different elements of dress, skin, hair and accessories. It is usually safer to begin like this and add greater variety later on.

(12)

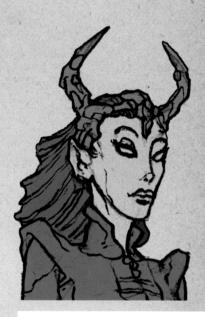

Shadow

With no shading the image looks flat (top image). Now add a simple shadow layer with a light grey on a new Multiply layer. This is very simple but will add a significant amount of volume to the figure. You can add several of these shadow layers, one on top of the other. Only one was used here to show what the minimum amount of shading can be.

(13)

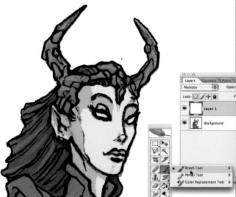

The basic trick with shading is to
imagine the light source in a certain
position and then place the shadow on
the opposite side to that. Be your own model
and use a mirror and a lamp to learn how to
draw accurate shadow. It's not a hard-and-
fast rule; on close study you will see me use
shadow where I shouldn't – it's a matter of
experience, instinct and personal style.

(14)

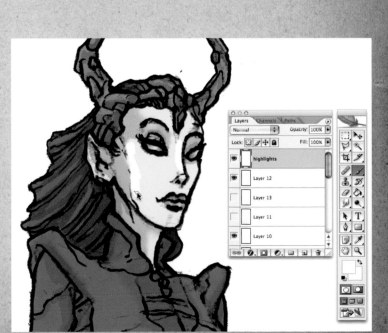

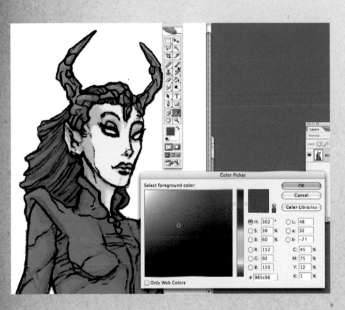

(15) It's very important to add a few extra colours now. Use
the same method you did for adding a shadow layer
but use colours complementary to the element you are
working on. Add some darker reds to the pink headdress and
some deep purples to the mauve hair. Also
add a brown/grey eye and lip colour.

Highlights

In order to finish off the most basic kind of
digital visual you must now add highlights, after
which you can continue to add more detail and
variation, or not. Add the highlights in white on a new
layer (you can't use a Multiply layer because the white
will just disappear). Again, imagine where your light
source is and add the colour accordingly. Always add
highlights to the cheekbone, forehead, nose and lips as a
matter of course.

(16)

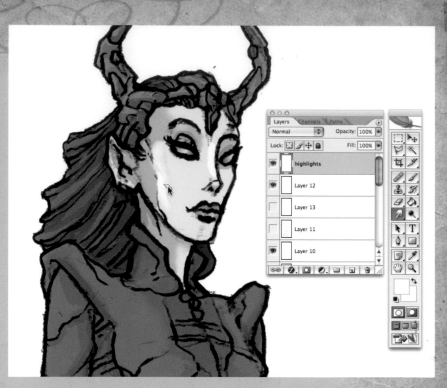

Use the Smudge tool, shown here, to smooth off the edges of the highlights – this has the effect of blending them even though the white colour is on a separate layer.

17

18 Now use the layer Opacity control to decrease the opacity of the highlights so they are less obvious and sit more comfortably with the rest of the image. The general rule is to paint in your shadow and highlights and then decrease them, sometimes to the point where they are almost invisible. This subtlety can make an illustration appear seamless.

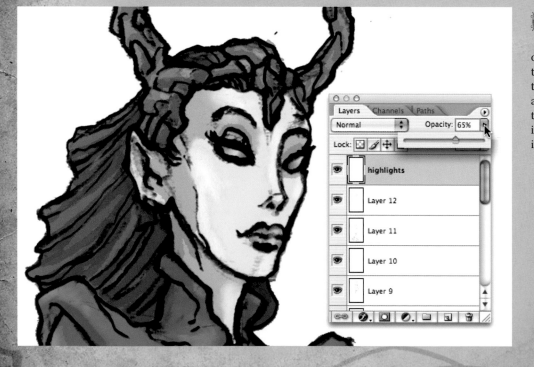

19 You can see how the most basic shadow and highlights will give your character just enough form and volume to express your idea. You can now take it further by adding additional layers of shadow and highlight or adding more colour – this process can go on indefinitely depending on how much time you have. You could also use various effects filters but here the image has been left in its simplest version to show what the minimum amount of work required can be.

Journey's End

The image of one of the fairy folk of Ireland is now complete. You will have seen by this exercise that working fast is a useful skill to develop and can be necessary – you may not always have time to attempt elaborate masterpieces or you may just wish to try out an idea before committing to a more detailed version. Speedy work may be hindered by a number of things, however, including a pet cat, as seen here ... Constantly removing this enormous creature from its position on top of my artwork costs me many valuable minutes of working time!

THE KOBOLD DWARVES

The dwarf tribes are spread throughout Northern Europe and Scandinavia, with their main base in the Harz Mountains, the highest range in northern Germany.

Dwarves are humanoid and similar to others from the Vættir family of nature sprites, such as elves. While elves are associated with nature and fertility, dwarves are associated with the earth, minerals and mining. They are fabulously wealthy and highly organized, renowned for their skills as craftsmen and their role as the manufacturers of armour to the various other species of the supernatural world.

Dwarves live and work in a network of tunnels and caverns carved out of the mighty peak known as The Brocken, a legendary mountain that has long been associated with witches and devils – superstitions encouraged by the dwarves to keep intruders away. The dwarf tribes themselves are based on the myth of the Kobold, a sprite that appears in German folklore and inhabits mines, stealing the tools of workers and causing other mishaps.

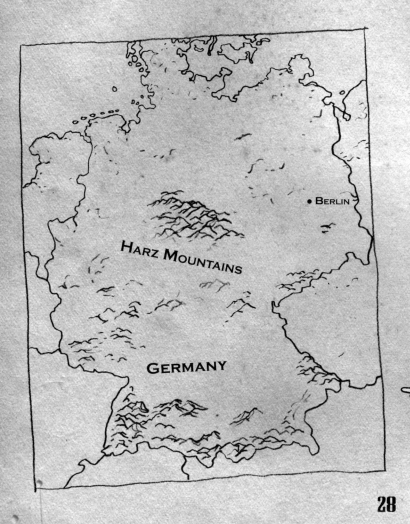

BERLIN

HARZ MOUNTAINS

GERMANY

EXPEDITION LOCATION: We cross the English Channel now and travel east to Germany. With access to both the Baltic and the North Seas, this country is rich in myths and legends brought by invaders and traders, and shares many stories with those of Norse origin. It is a land steeped in changelings, unicorns, elves and giants and is the home of Beowulf, Rhine maidens and powerful dwarven tribes.

 Dwarves are well represented throughout the genre of fantasy art and they are a fascinating subject, with distinctive characteristics that inspire rich and intricate imagery. I found plenty of existing material that inspired my dwarf design and added some more modern industrial twists to the character.

EXPEDITION PREPARATION

• TRAVEL GOALS:

Discover how to draw a figure using more tone at the pencil stage (moving on from the character of Flidais, which was simply drawn and coloured)

Learn how to employ a more detailed method of digital colouring to achieve a greater level of volume, depth and detail

• JOURNEY TIME:

About 30 minutes on pencils and one or two hours in Photoshop

• EQUIPMENT:

Fine pencil and eraser
Cartridge paper – 180gsm (80lbs)
Computer, scanner and Photoshop or Painter software

Expedition Discoveries

THERE ARE MANY SPECIES OF DWARF AROUND THE WORLD AND AS YOU EXPLORE GERMANY, EASTERN EUROPE AND SCANDINAVIA YOU ARE SURE TO DISCOVER MANY CHARACTERS TO PROVIDE INSPIRATION FOR YOUR ART, SOME OF WHICH ARE SKETCHED HERE.

SKARBNIK – The Polish word skarbnik means 'treasurer' and this species led miners to veins of ore and also protected them from danger. If insulted or abused, however, they would lead miners astray or cause cave-ins. Fortunately, the Skarbnik were said to give a warning by throwing handfuls of soil before doing anything mortally dangerous.

ALBERICH – Alberich was the King of the Dwarves and lived in an underground palace where the walls were covered with gemstones. He had a magic ring, a mighty sword named Balmung, a belt of strength and a cloak of invisibility. Alberich was said to have made a necklace for the Norse goddess Freya and also appears in Wagner's series of operas known as *The Ring Cycle*.

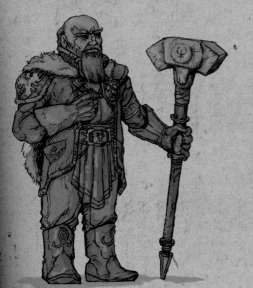

UNDERJORDISKE – Norse dwarves found their way into Scandinavian folklore in the tradition of the Vættir. These creatures were thought to be similar in appearance to humans but smaller, subterranean and dressed in grey. Underjordiske means 'the subterranean ones' and Scandinavian folk would always warn the Vættir before spilling hot water on the ground, to avoid angering the dwellers beneath.

PENCIL WORK

Start by drawing perspective lines that will give a dramatic emphasis to your figure. Show clearly the plane of the ground on which the dwarf will stand as dwarves, by nature, are solid fellows who appear rooted to the earth. Draw the crossed lines that will define the legs, trunk and shoulders of the figure. It's important to have a clear idea of how your figure will look before you begin, so make several rough studies to help you organize your ideas. Note that these basic guides already define the proportions of the figure, which will be squat and sturdy.

Work from the ground up to ensure that the dwarf is well positioned. As you draw, bear in mind the shape of the heavy work boots and the need to have the feet planted firmly on the ground. Massively exaggerate the proportions of the character, with very thick and short legs.

The trunk should be proportionally massive – draw it almost as wide as it is long and taper it downwards from extremely wide shoulders. Roughly draw in the chest muscles and ensure that the outline shape of the whole trunk arches backwards following the original line of the spine.

4 The head should be huge compared to the rest of the body – not like a human at all. Be prepared to push the proportions well beyond any plausible scale. Draw the whole jaw area comparatively large with a long line for the mouth drawn right across from side to side. The mouth will eventually be covered by a moustache and beard but it is important to place it anyway. Sketch the initial details of tools, straps and shoulder pads in basic volumes such as cubes and tubes.

5 Now add other details such as the protective shoulder pads and braces – all these elements should follow the lines of the body but stand proud from it. Construct the gun from basic volumes, starting with a simple barrel then adding 'cladding' around it to make it suitably fantastic and out of the ordinary. Now let's focus on the construction of the face for a few steps ...

FACE AND HEAD

6 Keeping your construction lines very light (as you may want to draw them several times) draw the usual squashed oval for the cranium but add a massive jaw and a very thick neck. Don't forget to add the all-important centre and brow lines, which form a cross on the front of the skull. Taper the neck outwards to the shoulders so it is wider than the head itself.

7 Now add a single line for the mouth, which should be large and turned down. Add eyeballs but note how they are partially covered by a basic eyebrow shape. The nose is interesting: the viewer is looking up at the figure but won't be able to see his nostrils because he has a very curved nose that bends right over and ends up quite flat to the moustache (when that appears). Add a basic volume shape for the ponytail of hair at the back.

8 Now develop the shape of each feature in turn. Add the goggles, hairline, beard and moustache as basic volumes – you will work these into greater detail later. All these features should sprout outwards from the face and sit on top of the basic volume you've drawn. Curve the hair and beard outwards from the point at which they meet the skull.

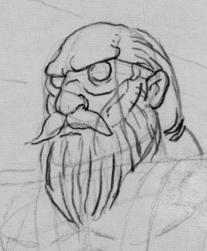

9 Draw the eyebrows so they also curve outwards from the skull and make them look similar to that of a gorilla. This brings us back to our rough face shape. The same rules apply to all aspects of the figure, so let's take a look at how to use the same approach for the hands …

Hands

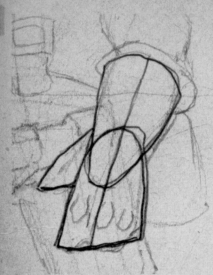

(10) Getting the hands right is essential. Begin them with three basic volumes, with the two main volumes, forearm and hand, overlapping. Curve the fingers under, around the tool that the figure is carrying, making the basic volume truncated and wide at the bottom but thinning out at the wrist.

(11) Draw knuckles across the front of the hand, towards the bottom, and add tendons in straight lines that flow back towards the wrist. Then add some basic muscle definition on the forearm, in this case a couple of simple lines that suggest a muscle running from the elbow towards the wrist.

(12) You have been working lengthwise down the hand so far. Now work crossways adding some more detail to the thumb and the arm muscles. Draw the outline of the glove, which must appear on the outside of your original arm shape.

(13) Now if you go back to the original rough (step 5), you will see more clearly how it came to look like this. It seems messy but all the essential construction is there ready for stronger lines to be added and unnecessary lines to be erased.

14 Draw the boots and trousers – as with the gloves, draw these outside the basic line of the figure, adding thickness and emphasis to the overall shape. Don't work too tight to the original outline of the figure: clothes have to have bulk and the boots should appear to be made of very thick leather. The left boot is seen face on, so your drawing will need to show it foreshortened, as seen here.

Start to 'clean up' your drawing by erasing some of the construction lines – but not all of them. It can be beneficial to leave in a lot of rough detail as it can help when you add shadow and tone. It is a delicate selection process, a balance between too many rough lines making the drawing messy, and too few, which may lead to the drawing losing the power of its original dynamic. Too many lines are usually preferable to too few. **15**

Detail

16 Now it's time to go into more detail. Go over the beard with a fine eraser, then back in with pencil, then again with the eraser. Keep repeating this process over the whole drawing to build up depth and detail. Then go over the image to do a final pencil line, selecting key elements that will have a harder line, including the outline of the figure and any important details.

Now add some shading. In this case a great deal of shadow has been used and a lot of the original rough lines helped guide the way in which these shadows were laid down. While building up shadow follow the lines of the body as it will help to add volume. **17**

35

Digital colouring

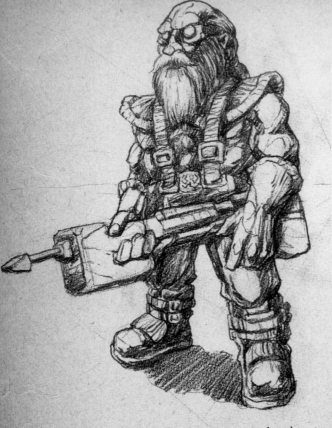

18 Simple digital colouring is based on a single colour to which variations of light and dark are added. Scan your pencil drawing and open it in Photoshop. Clean it up a little using the Curves control to make the lines darker and to eradicate a lot of the lighter, messier construction lines. Zoom in for a closer look and use the Eraser tool to remove anything obviously untidy.

19 Now pick a colour and begin to paint. This is where the shadow you added at the pencil stage becomes useful – it will help guide your colouring as the figure becomes darker and darker. Give each element of clothing, beard and skin a slight variation in colour. Stick close to the base colour and work within a narrow tonal range, leaning towards darker colours.

Shadow and highlights

20 Use the Dodge and Burn tools to create shadow and highlights. Begin with a wide brush and then work into it with successively finer brushes. Finish with a very fine brush, working over the shapes of each muscle and costume detail to create flecks and lines of light and shade, which will all enhance the sense of volume. For the goggle lenses, use the Burn tool on a low setting of about 5% to lighten a dot in the corner of each of the lenses. Sit back and look at it from a distance to check that it's not too bright. When a highlight is too bright we say it 'pops' because it pulls the viewer's eye directly to it.

The final colour and pencil layers can then be put through filters, such as the Watercolor filter shown here. These filters can help to pull all the elements of an image together into a consistent 'look'. However, it is vital that you have achieved a satisfactory level of finish manually before turning to such effects, as working with filters in the hope of creating the illusion of detail only results in images that look cheap and lazy.

㉑

Journey's End

Our first foray into Europe has resulted in this powerful dwarf painting. When developing early ideas for an image allow yourself the freedom to get out of the studio and sketch outdoors, perhaps at your favourite café. It's not the best way to focus on your work and tends to lengthen the process but it gets you into the valuable, lifelong habit of being creative wherever you are.

45

VAMPIRES

Vampires are defined as spirits that have returned from the dead to feast upon the blood or souls of the living and such creatures can be found in various forms all over the world.

Vampires are most common in Eastern Europe throughout the Carpathian Mountains, which stretch through Slovakia, Ukraine and Romania, and particularly in the Transylvania region, which is often associated with Bram Stoker's story of Count Dracula. Real vampire sightings have become rare in these regions due to Dracula-related tourism and it appears that most vampires have moved south into politically unstable regions such as Kosovo, where their activities attract less global attention.

The tradition of the elegant and handsome vampire who has a highly seductive quality dates back to the South Slavic vampires, who were renowned for passing themselves off as humans and even intermarrying with human females. This archetype was developed beautifully in the series of novels called *The Vampire Chronicles* by Anne Rice, of which one, *Interview with a Vampire*, was made into a visually sumptuous film, starring Tom Cruise, Brad Pitt and Kirsten Dunst. The success of this movie spawned a further genre of dashing vampire types.

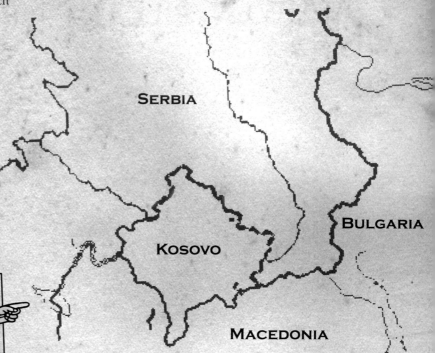

SERBIA

BULGARIA

KOSOVO

MACEDONIA

> **EXPEDITION LOCATION:** *Kosovo, the next destination on our worldwide expedition, is only a short trip from Germany. Situated in the politically fragile Balkan Peninsula, in south-east Europe, Kosovo has a fascinating history, particularly with regards to vampire lore.*

EXPEDITION PREPARATION

- **TRAVEL GOALS:**
Discover how to develop a character and execute it in ink using fine technical pens and some brush work

- **JOURNEY TIME:**
20 minutes on pencils and 30 minutes on inks

- **EQUIPMENT:**
Fine pencil and eraser
Cartridge paper – 180gsm (80lbs)
Bristol board – 130gsm (60lbs) or heavier

Light box
Technical pens – of varying widths including 0.3mm and 0.5mm, and a brush pen
India ink and a fine brush

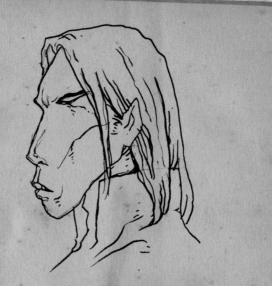

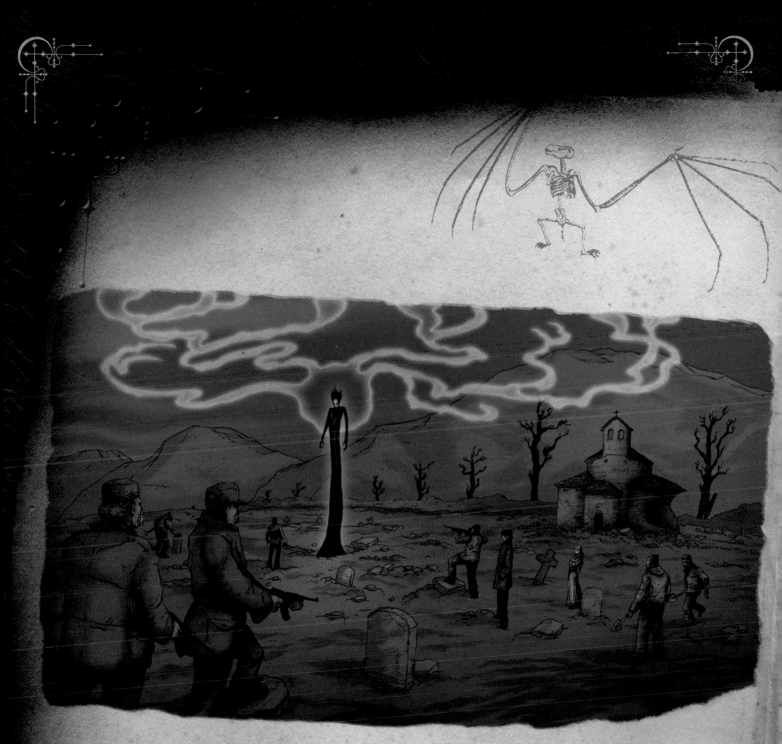

 I wanted this image of a powerful vampire rising in a graveyard to have an otherworldly quality and after the basic pencil work various Photoshop effects were used in its creation. Additional discussion of this image can be found on page 15. The step-by-step sequence starting on page 41 guides you through the creation of a vampire pen and ink image.

Expedition Discoveries

As you will discover on your travels, vampire lore is worldwide and there are countless creatures that would make great subjects, not to mention their nemeses, the vampire hunters.

Vampires of the World

If a vampire is defined as a creature that has returned from the dead to feed on the souls, blood or spirits of the living you would find that vampiric creatures exist in every country on Earth. Here are just a few from around the globe...

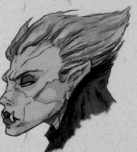

VETALA – In Hindu mythology the Vetala are hostile spirits who can inhabit the corpses of others and use them to move from one place to another. They can drive people insane and kill children but sometimes will protect the family or village to which they belonged in life. Vetala have a power of knowledge about the past, present and future and are much sought after by witches and sorcerers for use as familiars. Many Vetala stories eventually found their way into the epic tome *The Book of One Thousand and One Nights* (see page 95).

IMPUNDULU – the Impundulu, or 'lightning bird', is known amongst the Pondo, the Zulu and the Xhosa tribes of Africa. It appears as a giant black-and-white bird that has the ability to summon thunder and lightning with its talons. It is believed to be a servant or familiar to a witch doctor and is sent to attack their enemies. It has an appetite for blood and can transform into a handsome young man in order to seduce women.

LA TUNDA – La Tunda is a vampire woman of Columbian origin who can appear in the form of a victim's loved one in order to lure them to the forest where she keeps them in a trance. She appears first as a beautiful woman before transforming into a bloodsucking monster. In other stories she can be recognized by her wooden leg which sometimes appears as a wooden spoon. The Tunda is similar to the Patasola who also has a deformed leg and lures men to their deaths. This feature of deformed feet appears throughout folklore including the Deer Woman of Native American myth.

THE LOOGAROO – Stories of this creature are common throughout the Caribbean and Louisiana in the USA and the creature may be related to a French werewolf called the Loup Garou. The Loogaroo is a female vampire given magical powers by the Devil in exchange for offering him blood every night. The creature leaves its skin behind and transforms into a ball of blue flame that can be seen deep in the swamps. The only defence against it is to leave a pile of rice or sand at the front door, which will keep it busy as it has a strange obsession with counting every grain, a belief that stems from French and African voodoo.

MANDURUGO – A Mandurugo, which means 'bloodsucker', is a beautiful woman from the Philippines who transforms into a terrifying creature, flying through the night sucking the blood of its victims. It can pass unnoticed amongst humans and even get married. Newspaper reports claim sightings of the creature as recently as 1992.

Vampire Hunters

HUNTER'S TOOLS – A Romanian vampire hunter's kit was recently auctioned on the internet and is recognized by the Department of Culture in Romania, complete with a certificate of authenticity and a letter from a priest with instructions for use. Kits such as these were common in the Carpathian Mountains in the 18th and 19th centuries and this one was believed to have been made by a Transylvanian monk around 1870. The box contains a wooden hammer, four stakes, a prayer book, a crucifix, a syringe and bottles with Agheazma (holy water) and Usturoi (garlic). A tool called a Dentol was used to remove vampire teeth.

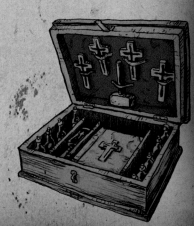

DJADADJII – This was a vampire hunter from Bulgaria who was able to trap his prey by 'bottling' them, much as sorcerers did with genies. The bottle would have a picture of a saint and was used to capture the vampire spirit, after which it would be sealed and thrown into a fire.

PENCIL WORK

Start working in pencil on cartridge paper and sketch in perspective lines. Think about how the vampire should be posed. He should be leaning back slightly, so draw the centre line with a slight curve to it. This drawing is to be a mid shot, from his head to his waist, so his legs won't be visible. Create the basic body shape using volume tubes and cubes but keep them loose and rough, not too rigid. Don't show detailed musculature as the clothing will not be the sort to show off the anatomy. Draw a long and bony hand to emphasize the character's macabre nature. ①

Draw the basic elements of the clothing, ② including the shape of the cuffs, the collar and the line of the waistcoat. The coat has a sharp, angular shape that will contribute to the elegant styling of the figure. Define the waistcoat with a single line that sweeps out into two points at the bottom.

Now add the basic elements of the face: ③ we'll come back to this in more detail in steps 6–13 but note how the face is looking slightly downwards and follows the lines set up in the basic structure. Draw the hair sweeping away from the head to add flair.

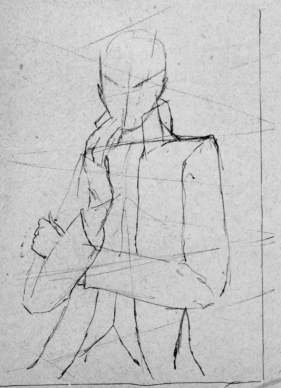

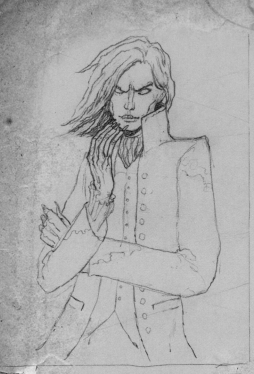

④ Start to strengthen up the lines of the clothes and face and begin adding some details such as shirt cuffs, pockets and a neck cravat. Try a few different things with clothing until you can settle on a level of detail that you are happy with. Long lines of buttons are typical of the 18th century style of aristocratic clothing.

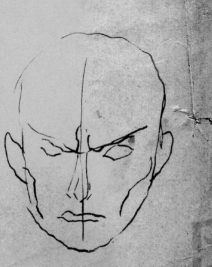

Using line work add shadows under all the buttons and on the neck, around the hairline, under the arms and on other areas of clothing. Finalize the drawing with a good strong outline. Go over all the lines at least three times, gradually building them up to suggest shadow and to give strength and form to the figure. ⑤

THE FACE

⑥ Now let's go back and take a closer look at how the face is drawn. Begin with a standard face shape with the frown already in place, denoted by two downward pointing lines that meet in the middle.

Sketch in the basic shapes of the ⑦ eyes, nose and mouth. Note the high cheekbones – an essential feature of any good looking vampire. All the proportions are typical of a normal human being. Always draw the line of the mouth in before you add the nose as this will make it easier to achieve correct facial proportions.

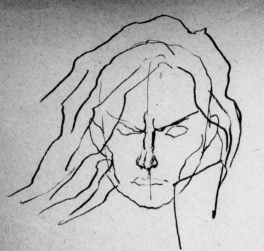

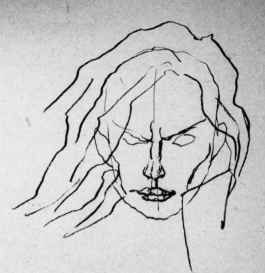

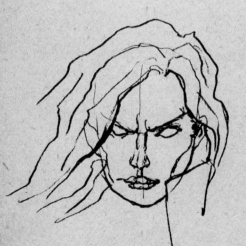

8 Draw the nose in more detail – a good masculine nose will have a broad bridge that narrows and then widens again at the nib. Notice how the parting of the hair is in the same place at both the front and back of the head. For thicker hair, use fewer lines when constructing the basic shape to suggest a more luxuriant form.

9 For an attractive vampire draw a full mouth with both the upper and lower lips fully delineated. An upwards curve of the mouth at the sides gives the creature a slight smile, even though he is frowning.

10 Now tighten up the features by going over the main lines of the jawline, eyebrows, eyes and hairlines. Strengthen one side of the nose (not both) and beneath the nose where there will be a small amount of shadow. Eyes are always more attractive if you add thicker lines around them; this is typical of females but also works for males.

11 Clean up the face with a fine eraser, as shown. Get rid of the original construction lines and then go back over any lines you have erased. You can repeat this process as often as you need to until the features start to strengthen.

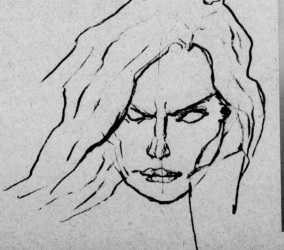

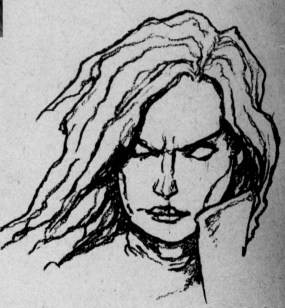

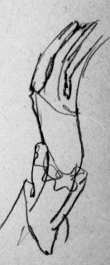

12 Now work into the drawing with some final details, which will include adding more detail to the hair, more shadow around the jaw and hairline and further detailing around the eyes. Subtle work like this is not always easy to see but contributes a great deal to the overall strength of the character.

This process of thickening and building up the lines will naturally result in additional shadow and tone, which gives volume to your drawing. You can afford to be quite messy at this stage as a lot of the variation in pencil tone will disappear when the illustration is inked. Just use shadow at this stage as a guide for when you add ink. 13

Hands

The hand touching the face is important to the overall effect in this drawing. It gives the character a thoughtful look and importantly, is the only real evidence that the figure is a vampire, apart from the blank eyes. Begin with the basic shape of the hand but make sure the fingers are very long and form a long curve outwards from the shape of the palm. 14

Be very loose with your pencil and put in some rough details including the outline of the cuffs. Keep your work rough at this stage and feel your way around the shape of the fingers. You can see here how the final shape is only just beginning to take shape. 15

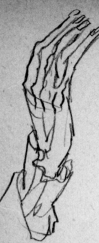

17 Now refine the shape of the hand, in particular making the knuckles of the fingers wider than the rest of the finger. Add more detail to the shirt cuff, developing the folds as seen here. Add some inside lines on them. The cuff of the coat is now fully formed.

16 As you draw the hand there are two clearly defined elements that you need to aim for. The first is that the fingers should be very bony and ancient looking. The second is that the fingernails should be long and flat at the end. Make the bony knuckles prominent and draw some tendons.

Add tone and shadow and a strong outline using the same process as the face. Keep going back over the lines to strengthen them. 18 Don't press hard with the pencil, allow the darkness of the line to build up gradually by repeatedly going over the same lines. The other hand isn't particularly important but try to ensure that it wraps around the arm. Use a mirror and observe yourself.

INKS

19 You can ink directly on to your original drawing but it is a good idea to use a light box to copy the image for three reasons. First, if you make a mess of the inks you can start again, as your original drawing is still intact. Second, cartridge paper is used for the pencils as it allows more tone, but smooth Bristol board is better for the inks as you can achieve a cleaner line because the ink doesn't 'bleed' as it would on cartridge paper. Third, working on ink over pencil can get messy, so working on a fresh sheet results in a crisp, clean ink drawing.

Switching to the Bristol board image, start by going over the whole piece with a fine line, in this case 20 with a technical pen with a 0.3mm nib. Add a lot of detail even though much of it will eventually be covered in black. There is no correct time to decide when the drawing is finished, you may be happy with it like this, with a single consistent line and very little shadow.

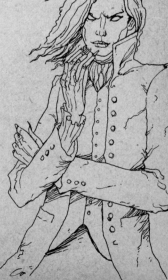

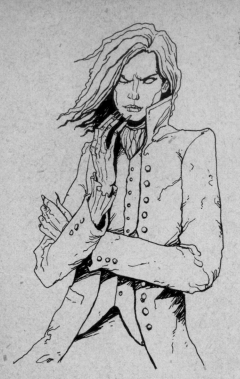

21 Now go over most of the lines again with the same pen or a slightly thicker one. This gives more 'life' to the lines as they will begin to vary in thickness. Start to fill in the more obvious shadow areas, such as under the hair and under the forearms.

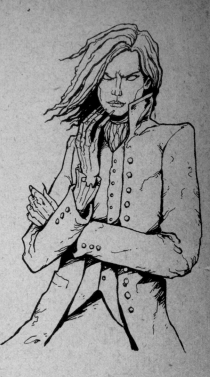

Fill in with shadow in all the 'corners'. Go around the outline of the whole figure with a slightly thicker 0.5mm nib, to boost the impact of the drawing. You could leave it at this and call it complete or add more black. It is a good idea to scan the drawing at this point in case things don't work out at the next stage. **22**

23 Use a brush pen or a brush and India ink and begin to fill in areas in black. Think about where the light might land on the coat. Look at photo references of 18th-century frock coats made from satin and leave white areas to show this slightly shiny look.

Now start to fill in with black ink. Don't be afraid to go over the shadow and detail you added earlier. Paint your lines to follow the lines of the body, even if they become invisible to the eye in the final drawing. There are no rules about what to fill in – it's a matter of experimentation and personal choice. **24**

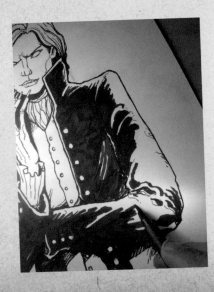

25 As you go along you might find that certain areas left white don't work anymore and you need to go back and fill them in. There is no obvious light source here so keep shadow to the areas where shadows would always appear but, for effect, you could have light areas down one side of the figure.

46

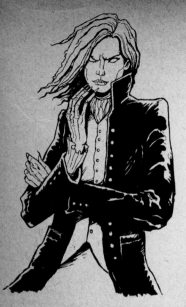

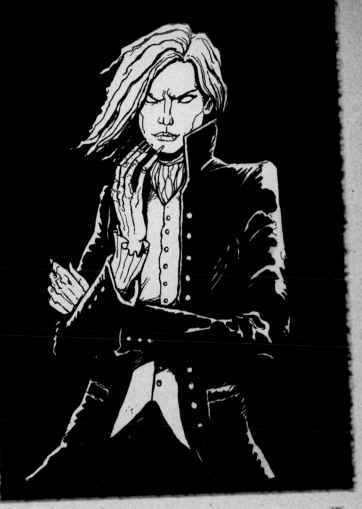

26 The final ink drawing is now complete, with the black covering most of the original shading. Nevertheless, the few thin lines that are left are important to the overall look. Sometimes you may cover up detail that you have put in earlier; this is part of the process of discovering the image as you go along – you never really know what twists and turns a drawing will make in its development.

27 You now have a few more options. One is that you could add a background shadow to enhance the drama of the figure. There is no visible division between certain parts of the figure and the shadow behind him, so this gives the impression that he is melting into the shadows.

Another option is to add a full black background, which obscures the outline of the figure giving the impression of him emerging from darkness ... as all successful vampires do. **28**

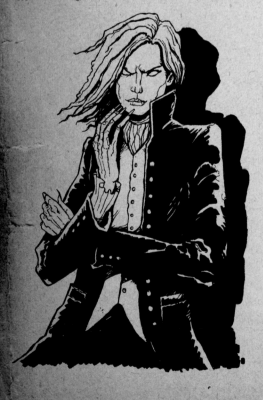

Journey's End

Our trip to vampire country is over all too soon and you may be concerned that this image took less than an hour to complete. If you are a beginner you may find that daunting. However, before doing this image I spent two hours on a pencil drawing that went so horribly wrong I ended up tearing it up and throwing it in the bin. This should be encouraging – even after five books in as many years and thousands of artworks produced there is still no certainty that any drawing will work out first time. As an artist you will always be meeting new challenges that will test your patience and confidence. As you improve though, you will find that you need to refine things less and often get all the elements right first time.

Kosovo

WEREWOLVES

The belief in werewolves, people who periodically change into wolves, dates back hundreds of years and has its origins in the remote mountain regions of Eastern Europe. The word *'varkolak'* means 'werewolf' in most Slavic languages.

Most of us are familiar with the appearance and behaviour of werewolves, thanks to Hollywood, but this image is an archetype and there are many other creatures classified as werewolves. It is said that werewolves may be people who were sinned against in life and have returned for revenge. Other stories say that they were sinners who have been damned to return to feed forever on the living. In north-west Bulgaria stories of the Varkolak are common. Although the word means werewolf, the creatures it describes are synonymous with vampires. One belief holds that when a bandit dies he will become a Varkolak 40 days later.

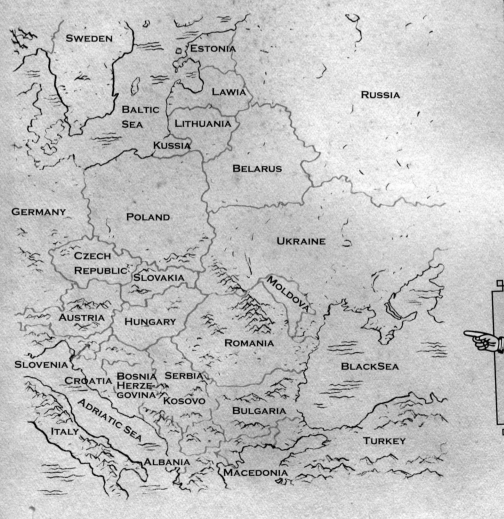

> **EXPEDITION LOCATION:** We travel north now through Bulgaria to the banks of the River Danube. Superstitions and myths abound in this country and its rich history has been written by many migratory peoples over the centuries. In neighbouring Romania evil demons, malign spirits and werewolves that wreak havoc are often associated with solar eclipses.

 For the inspiration for this painting I didn't look at many illustrations of werewolves but studied real wolves and found some interesting photographs of dogs fighting, which provided excellent anatomical reference. This image records just a few werewolves you may discover on your travels. See overleaf for details of this fearsome group.

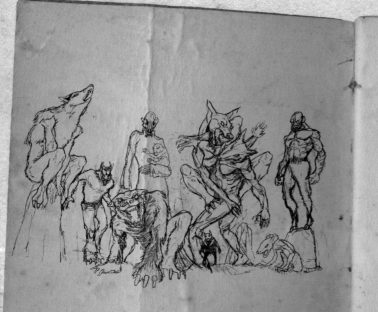

EXPEDITION PREPARATION

• TRAVEL GOALS:

Discover how to create a painting with the minimum of materials and time
Dispel the myth that paining requires an arsenal of brushes and paints, a huge expensive canvas and a great deal of spare time

• JOURNEY TIME:

About three to four hours, allowing for drying time between stages

• EQUIPMENT:

Bristol board – 20 x 30cm (8 x 12in) sheet, 180gsm (80lbs) smooth surface
Black technical pens and a fine brush pen
Gouache paints – cheap ones or a children's set
Brushes – don't skimp on brushes, as cheap ones leave bad marks and you can't move the paint around properly with them

Werewolf Pack

PRICOLICI – These particularly violent werewolves from Romania were said to be dangerous men in their previous lives and even recently there have been reports of people being attacked by Pricolici.

VILKCACIS – This creature is from Latvia and is the most similar to the typical Hollywood type. It can eventually be returned to human form. They are generally violent but are sometimes helpful to humans, often leading them to treasure.

STRIGOI MORT – These creatures are most often associated with vampires or zombies in Romania and are said to have two hearts. A Strigoaica is a witch and in Slovenian and Istrian mythology a Striga is usually a female who can only be killed while she is feasting on the life force of her victim.

VARKOLAK – In north-western Bulgaria it is said that the Varkolak can devour the sun and the moon, an explanation of an eclipse. In Pestani in Macedonia, the word 'volkolak' denotes the mature stage of a vampire's development, one who has survived for 40 days after death and attained human form.

KOERAKOONLASED – These Estonian creatures are humanoid with dog heads and are said to be particularly vicious, hunting in packs and showing no fear of humans.

DREKAVAC – In Serbia a Drekavac comes from the soul of a dead unbaptized child and can appear as a child, a bird, a dog or a wolf-type human. The creature most often appears during the 12 days of Christmas, known as unbaptized days in Serbia. It is said that a person will dream about a Drekavac before seeing one.

STRYZGA – With two hearts, two souls and two sets of teeth these Slavic creatures from Poland stalk travellers and eat out their insides. Burying a deceased person face down with a sickle around the head is said to stop them returning as a Stryzga.

PLAKAVAC – In Herzegovina this creature arises from a newborn strangled by its mother. It rises from its grave at night and returns to its previous house screaming.

SOBOLAN – This giant rat-like creature has some human characteristics.

LASKOWICE – These are wild men who live in the woods in Poland and have the bodies of satyrs or goats. They guard the forest and have an affinity with the wolf.

① The image of the werewolf perched on a rock requires a perspective where you are looking *up* at the top half and *down* at the bottom half – the horizon line is exactly halfway up the image. The anatomy of the werewolf is more human than wolf, with the wolf part concentrated in the head and the paws. Using basic volumes to delineate the components of the figure is shown here as a guide but strive towards a more fluid, expressive approach with your work, requiring fewer construction lines.

② Use photographic references to get the shape of the wolf's head correct. Using light lines, rough out the basic body shape and give an indication of the fur covering the human body parts as well as the wolf's, particularly on the throat, chest and back. As your skills increase you will be able to sketch figures without the need for construction lines.

TEETH

③ Start to add more detail to the head and pay special attention to the teeth, which should be razor sharp and curve backwards into the mouth. Draw the gums so that they are curled into a snarl that exposes the teeth. Canine teeth consist of long incisors or 'cutting' teeth at the front, behind which are crown-shaped mandibles or 'chewing' teeth. Look at other animals and reptiles such as crocodiles to get ideas for more interesting teeth shapes and types. Ears pointing backwards are typical of canine behaviour when threatened or preparing to attack.

FUR

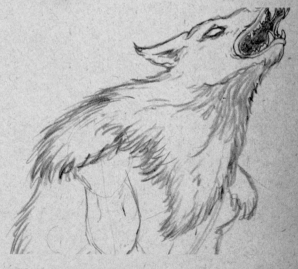

④ Begin drawing the fur in more detail by laying down pencil strokes that follow the line and flow of the body. Don't press too hard with the pencil – use soft, rapid strokes to build up the density of the fur.

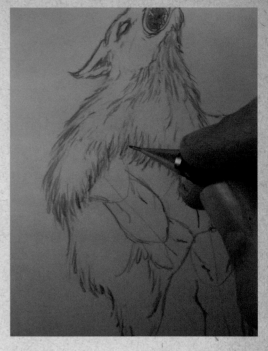

⑤ Using a fine eraser break up the heavy pencil lines – this serves to create tonal variation in the fur and will also add depth to the image.

Add more pencil lines to build up the impression of the thickness of the fur. Vary the pencil strokes slightly so they are not going in precisely the same direction as the original lines you put down. This helps to build up fur density. ⑥

⑦ Repeat the process of erasing and pencilling for as long as you need to. Here you will see it hasn't been done enough as the fur still looks patchy in places and, although it is starting to resemble a luxuriant coat, it still requires more work around the throat, chest and shoulder.

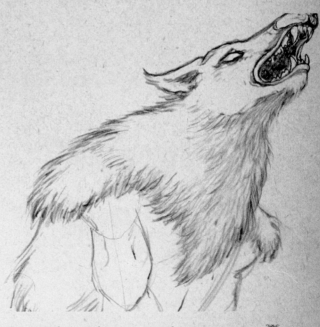

Here it is just about right. Knowing when to stop is a matter of personal choice. The final pencil lines will be covered with paint so all your hard work will be lost but it is useful to have every detail on the page at the pencil stage to avoid difficulties later when painting. Take a close look at your image and continue working if needs be. ⑧

9 Go over the rest of the figure with a soft pencil, building up the lines to increase the definition. Add more detail in the form of short pencil marks. Step back from your drawing at this point and look at it as a whole, judging which areas need to be strengthened and if any parts ought to be erased and re-drawn.

10 Add the shadow with soft strokes that work delicately into the fur. When adding shadow consider where the light source is, but also think in terms of the clarity of the image and how it will look when painted. The mane will be painted in lighter colours so use less shadow on it. By comparison, the arms, legs and torso will be much darker when painted, so add heavy shadow to them.

Inking

11 Use technical pens for the fine lines and a brush pen for large areas of black. It's ok to leave some areas of pencil showing as these will contribute to the depth of tone when you come to the painting. A very fine brush can also be used to delicately ink in the fur, as brushes give a varying line that is much more suitable for the depiction of flowing fur and hair.

Base layer painting

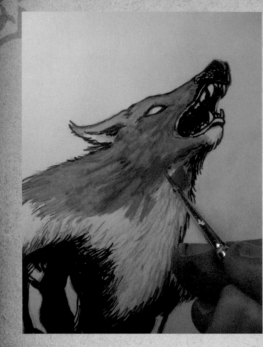

 Mix up a large quantity of mid blue gouache by mixing blue, white and water. The paint must be a medium consistency for working on board. If it is too wet the board will buckle and the paint will not be strong enough to create a good base layer. If it is too thick it will be difficult to apply and will cover the ink lines, which should still be visible through the paint. The paint will dry slightly lighter than it appears as it is applied. Work quickly and apply the brushstrokes in the same direction as the fur. The mouth and teeth were inked so do not need to be painted here.

(13) Mix a quantity of white paint with a hint of blue. When the base colour is almost dry start adding this new colour. It is not exactly a highlight but adds texture and variation to the base. Begin by adding highlights in the obvious, lighter places using fine strokes in the direction of the fur and following the contours of the head around the cheekbones, the edge of the jaw and along the top edge of the nose, ear, neck and shoulders.

Background

(14) For the background you can mix a far wetter colour – use something complementary such as a blue and red mix to form purple. Apply this with a larger brush and swirl and stipple the brush to create texture. Using colours that are wetter, more diluted, will result in much more variation in colour and texture and allow you to build up texture in successive layers.

Now work a second layer of a complementary colour or dark blue and build it up (15) over the original purple background colour. Working on canvas would allow you more freedom to build up many layers but board will start to break up quickly so use your paint sparingly. The final base colour should have enough variation in its colour and texture to work as a good base for the shadow layer.

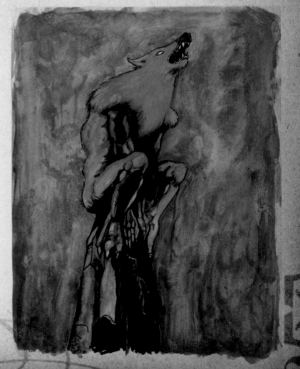

Adding shadow

⑯ Now mix a darker blue – wet enough to see through but not so wet that it will be absorbed by the base layer. Work over the shadow areas and add shadow to the base layer. Start from the areas deepest in shadow, such as under the arm, and work outwards towards lighter areas – as the reservoir of paint on your brush runs out the dark and light areas will gradually blend.

Use this same colour to add extremely fine detail ⑰ over the whole figure. These details will fade as they dry. Gradually build up layers of detail by going over and over them. You may find that these details seem to disappear as they dry but they do contribute to the overall final effect.

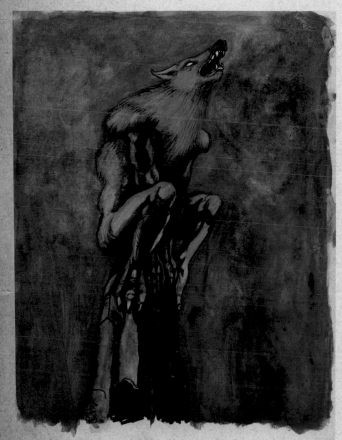

Adding highlights

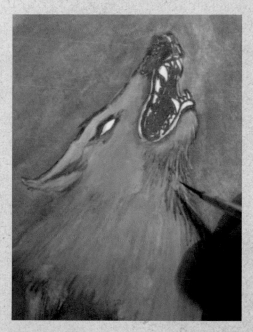

⑱ This stage can take quite a long time as you must continuously work over the shadow and gradually build it up, all of which leads to greater depth and tone. You may find your painting looks too dark but don't worry – this is quite normal. You will have the opportunity to lighten the image when you come to add highlights.

⑲ Leave the painting to dry almost completely before mixing some fresh white paint. The mix should be strong enough to be visible but not so strong that it won't mix with the colours underneath. Add highlights along the outer edge of the fur and other areas. You could add subtle highlights in the darkest parts of the shadow areas. This process is a matter of trial and error so experiment to develop your techniques.

20 Apply highlights with a fine brush along the outer edge of the whole figure, down the right-hand edge of both legs and arms and on all toes and claws. It is usually effective to add strongest highlights along one outer edge with more subtle highlights blending in to the darker areas of the rest of the painting.

21 Now add a final layer of shadow. Mix up a very dark blue and apply it with a very fine brush, working in the direction of the fur. This extra detail will serve to build up the texture of the whole image and should also be applied to the shadowed areas and the rest of the figure as well as the fur.

UNDERMIXING

22 In the later stages it can be fun to use a method called undermixing. To do this use three complementary colours and mix them together but not entirely, leaving them so they form a mixture of several different tones and colours. Use this melange to add a variety of colours and textures to background areas to increase texture and depth.

23 Mixing three colours in this way will give rise to a whole variety of grades of colours, which can be used for building up heavily textured areas. Use the brush to stab at the paint, stipple it, move it around and see what textures you can produce. There is a limit to this with a board surface but you can continue this process almost indefinitely when working on canvas.

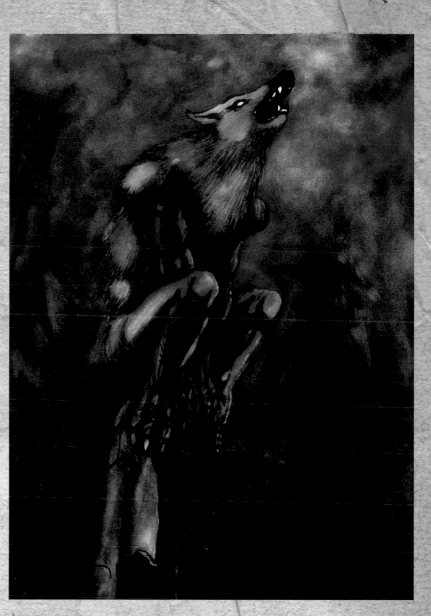

24 The technique of undermixing can be particularly useful when creating areas of cloud and smoke or heavily textured areas such as rock or water. Use this method to create the atmospheric background, as seen here.

Once the painting is finished you have the option of scanning it and using Photoshop to adjust the colours, tidy up mistakes or even add filters, as seen in this example where the image has been passed through the Diffuse Glow filter. **25**

Journey's End

Our expedition to Bulgaria has produced a powerful image that I hope you are proud of. Needless to say, painting is a slow and laborious task that requires patience and skill to master. And although it would be ideal to work on large, expensive canvases this exercise shows how it is possible to gain some experience with the simplest of materials.

Българиа

THE MARA

I n Scandinavia and Germany the Mara is a type of spectral visitor that haunts victims in their sleep, much like the Incubus and Succubus of medieval legend.

The words for nightmare in Norwegian and Danish are '*mareritt*' and '*mareridt*', meaning 'mare ride'. Stories tell that the weight of the Mara caused a feeling of suffocation, a sensation we now call sleep paralysis. The Mara were also said to ride horses and tangle their hair, causing 'mare locks'. In Sweden stunted pine trees growing on coastal rocks are known as '*martallar*' (mare pines). In English folklore, hags performed the role of the Mara, giving rise to terms such as 'hagridden' and 'haglock'. In Germany the Maras' activities were given to the dark elves, and the word for nightmare in German is '*albtraum*' or 'elf-dream'. The free-roaming spirit of a sleeping woman could become a Mara, either out of wickedness or as a curse for being wicked in some way.

EXPEDITION LOCATION: *Our expedition takes us to chilly Norway, with its fjord-indented coastline and mountains cloaked in snow. The Scandinavian countries are a rich source of myth and Norse mythologies, closely related to German mythology, have a worldwide influence. The country's vast uninhabited forests and thousands of lakes have given rise to many tales of wood and water spirits.*

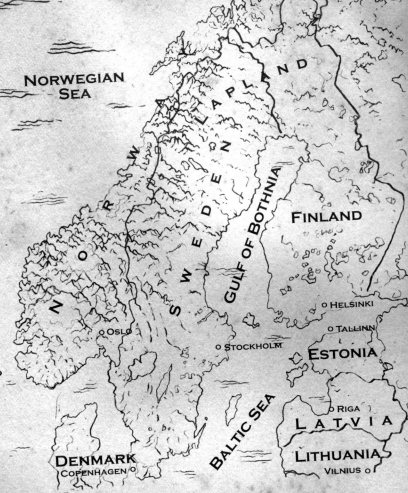

NORWEGIAN SEA

LAPLAND

N O R W A Y

S W E D E N

GULF OF BOTHNIA

FINLAND

O HELSINKI

O TALLINN

ESTONIA

O OSLO

O STOCKHOLM

O RIGA

L A T V I A

BALTIC SEA

LITHUANIA

VILNIUS O

DENMARK
COPENHAGEN O

EXPEDITION PREPARATION

- **TRAVEL GOALS:**

Learn how to draw a fascinating woman
Discover how to use watercolours to produce simple but striking colour effects without needing expensive materials or computer equipment

- **JOURNEY TIME:**

About one hour – you have to work fast with watercolours …

- **EQUIPMENT:**

Pencil and eraser – a 0.9mm HB propelling pencil or a normal 2B pencil
Watercolour paper – fine grain 180gsm (80lbs)
Watercolour paints – any will do but the more expensive ones have richer colours
Watercolour brushes – various sizes from 000 to thick (buy at least two good quality brushes: the best ones have very soft bristles so water flows off them easily)
Light box – not essential but very useful

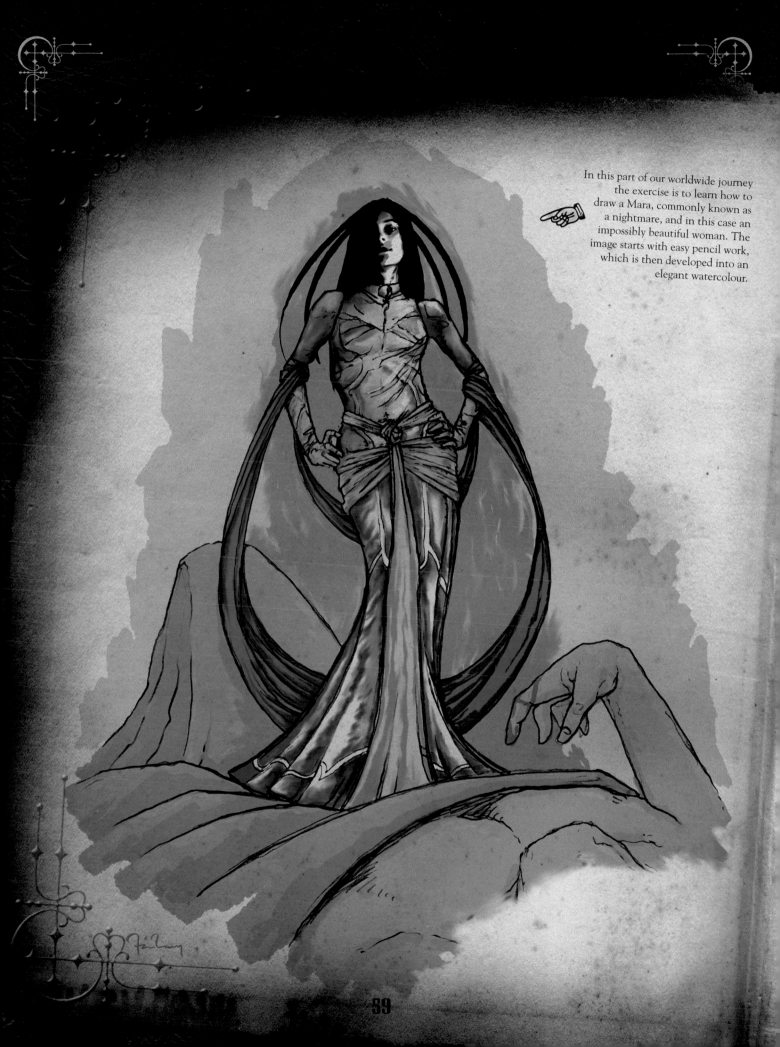

In this part of our worldwide journey the exercise is to learn how to draw a Mara, commonly known as a nightmare, and in this case an impossibly beautiful woman. The image starts with easy pencil work, which is then developed into an elegant watercolour.

PENCIL BASICS

Begin by doing some rough sketches to determine the exact pose of your character. Use photographs of models or friends as references (but ask their permission first and make sure they know in advance how they will be portrayed). Using a fine propelling pencil for accuracy, draw rough perspective lines to give a simple framework to hang the figure on. Start to build the body shape as volumes to get the proportion correct. As you draw, tilt the torso back and make the waist slim, both of which will point into the centre line and will influence the lines of the dress. These flowing lines will ultimately become the sweeping skirt.

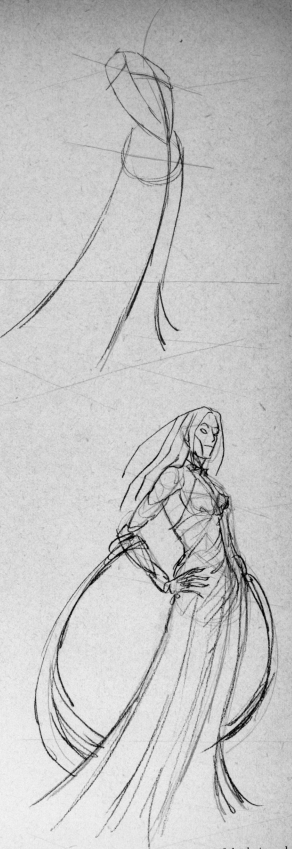

② Add the basic volumes of the arms and head and shape of the ribcage. The neck is long and the head juts forwards in a confident and commanding manner as befits a nightmare. Although these drawings are built up from volumes, aim to get your pencil lines moving freely and naturally, something that will develop with time and practice.

③ Use flowing lines to build up the shapes of the hair and dress. Follow the lines of the body to create volume around the torso and on the arms and hands. Build up detail in successive sweeps, moving around all the different parts of the drawing, jumping back and forth from the various features. The same pencil is used throughout this stage. When you begin use very light strokes, which are easier to erase, and then as you continue you can start to use a stronger line.

4 You now need to finalize the details. But how do you arrive at a beautiful face that expresses both confidence and a bit of danger? Faces can take years of practice so it's important to dive in and be prepared to make mistakes – only time and repetition will improve your results. The next few steps will guide you through it …

Expedition Discoveries

As you trek around the myth-rich countries of Eastern Europe and Scandinavia, be careful or you might discover other female night riders on your travels …

GAILA – this spirit of the night from Lithuania is said to possess people and animals in dreams.

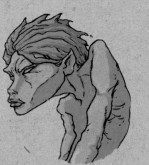

LIDÉRC – a strange, chicken-like creature from Hungary that shape shifts and attaches itself to people to become their lover. If the victim is a woman, the Lidérc sits on her body, sometimes sucking her blood, which makes her weak or ill. The Hungarian word for nightmare, 'lidércnyomás', means 'Lidérc pressure'.

NOCNITSA – mythical stories from Poland tell of the Nocnitsa or 'night hag', who is known in Bulgaria as Gorska Makua, a creature who torments children at night. Mothers place a knife in their children's cradles or draw a circle around them for protection, probably derived from the widespread belief that supernatural beings fear iron.

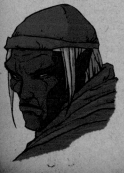

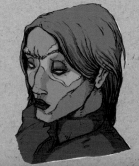

ALP – in Germany these creatures are said to attack females at night, control their dreams and cause nightmares. They are associated with vampires because they sometimes drink the blood from the nipples of men and young children.

Facial details

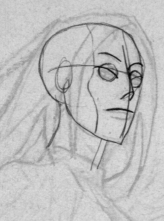

5 Construct the basic shape to show a long neck with the cross line of the eyes and centre of the face. As you become more confident you will find you don't need to use these basic proportional methods but it's a good place to start.

6 Add large ovals for the eyes and give each one a single slanted eyelid. Draw a simple straight line for the nose with a pinched arrowhead for the nostrils. A single line for the mouth will do for now. Note that she has quite a large jaw, which helps to give the impression of confidence and a tough attitude.

7 Draw an inwardly curving line beneath the straight line of the nose. Add pupils and eyelashes on the existing eye construction but add a new line for the eyelids. Draw the rest of the mouth, making the lower lip quite large.

Hair

8 Draw the basic hair shape – this should consist of long flowing lines that follow the overall dynamic of the figure. These lines will make a great contribution to the overall power of the figure. Hair is a great way of adding movement to a static figure and emphasizing the overall lines of energy that flow through the drawing.

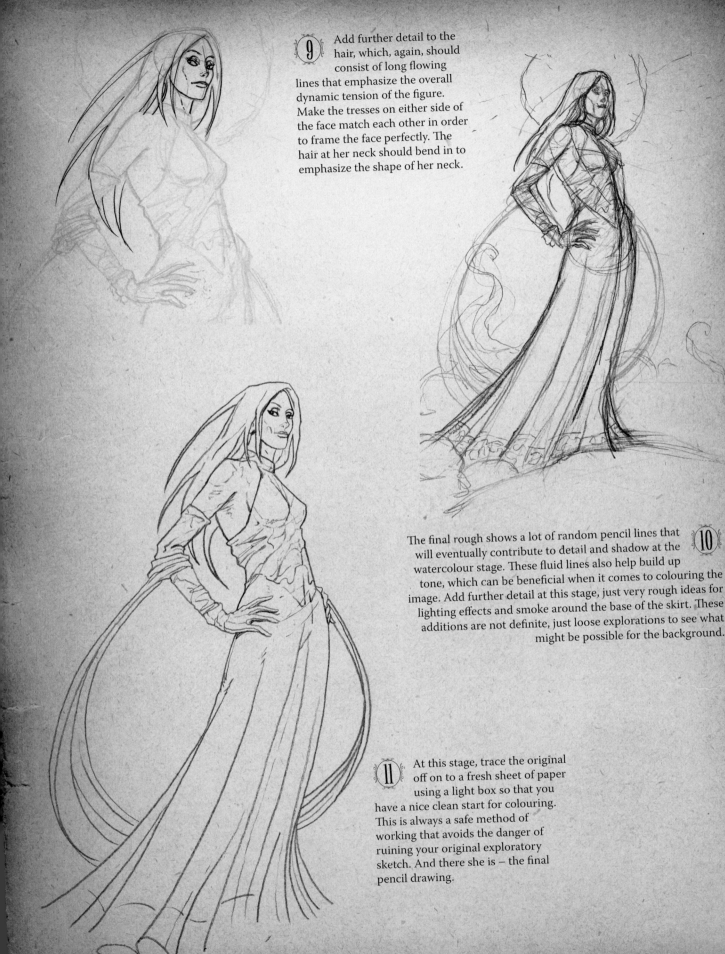

9 Add further detail to the hair, which, again, should consist of long flowing lines that emphasize the overall dynamic tension of the figure. Make the tresses on either side of the face match each other in order to frame the face perfectly. The hair at her neck should bend in to emphasize the shape of her neck.

10 The final rough shows a lot of random pencil lines that will eventually contribute to detail and shadow at the watercolour stage. These fluid lines also help build up tone, which can be beneficial when it comes to colouring the image. Add further detail at this stage, just very rough ideas for lighting effects and smoke around the base of the skirt. These additions are not definite, just loose explorations to see what might be possible for the background.

11 At this stage, trace the original off on to a fresh sheet of paper using a light box so that you have a nice clean start for colouring. This is always a safe method of working that avoids the danger of ruining your original exploratory sketch. And there she is – the final pencil drawing.

WATERCOLOUR WORK

Begin by mixing some colours and doing some tests on scraps of paper. You will need two shades of blue and a pale blue-grey for shadow and some red to increase vibrancy. Watercolours are highly fluid and blend immediately so it's down to trial and error as to which colours you choose. Blues have a tendency to be very heavy and it can be quite difficult to get a really bright, sky blue like the one shown here, so you may need to use more water in the mix than normal to keep it light, which is why it is essential to do colour tests first. **(12)**

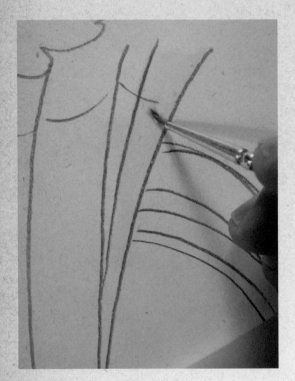

You have to work fast with watercolours but they are also easy to manipulate and push around. Start by laying down some clear water. Using a fine brush, such as size 000, work very carefully up to the pencil lines, in this case the long flowing lines of the dress. Don't go over the other side of the line as the colour will bleed over when you add it. However, if you do it doesn't matter too much as you will have plenty of time to blend the colours in as you go along. **(13)**

Add your first colour in a long flowing line that follows the line of the dress. Work upside down and move from the bottom to the top of the dress. As soon as you have added your first blue, add your second, darker blue on the inside or outside of the fold of the dress to create depth. Repeat this process across the dress. If you get patches or bad blends keep working into them lightly with the brush and they will gradually blend. **(14)**

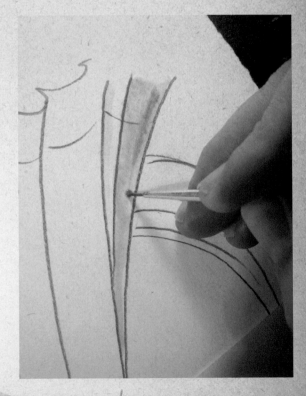

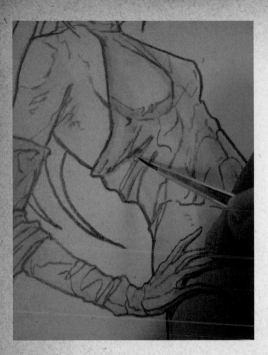

15 Cover the upper part of the dress and gloves with a pale blue using swirling motions of the brush that roughly follow the lines of the dress. As this dries add the darker blue and spend plenty of time doing this. If it is too dark add a little water to keep the colours fluid and moving. As a general rule for beginners it is better to begin with light colours and then add darker colours when the first layer of colour is still slightly wet. Building up layers of colour from light to dark allows you to create much more variety and depth in the final image. When you add darker colours start in the areas where the shadow is, such as the folds of the dress or the background closest to the figure, and work away from the line into the lighter areas – this will create realistic blends from shadow into light.

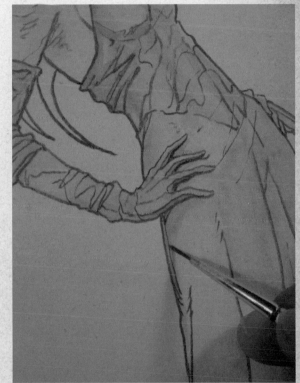

Continuously build up shadow in this way, creating layer after layer of depth. You can 16 also add clear water to make other areas fainter. Be careful to work right up to the lines and look out for obvious patches where there is no colour. With a drawing like this it is necessary to have a tight edge. Use an even darker blue to go over all the pencil lines and build up the shadow even further.

17 Now build up background textures by the same method. Add clear water first and then use two different colours and allow them to bleed into each other, pushing the colours around and experimenting with making textures with the brush – be careful when working up to the edges of the figure though. Use a larger brush for the background and keep a tissue or sponge handy to dab away excess colour and mistakes. The tissue or sponge can also be used to create texture effects but experiment on a scrap of paper first.

18 Use water to correct mistakes and tissue to take off colour. You can also use tissue to create patterns in the colour while it is still wet. Experiment with different types of tissue, cloth or other materials to make interesting textures – even twigs and leaves can create unusual patterns.

19 With the colour base complete you can now consider adding shadow. Here a very pale shadow has been added to the skin, with a blue that was so light it was almost invisible. Flesh can be hard to achieve with watercolours but as the Mara is a ghostly creature it is reasonable to use a very pale colour. You can approach delicate areas tentatively by building up from very light shadow and getting progressively darker. There is a danger that you may go too far and the colours will become muddy but it's a risk you have to take. If it looks like it's going that way, dab on some water with a clean brush and use a tissue or cloth to 'erase' the colours.

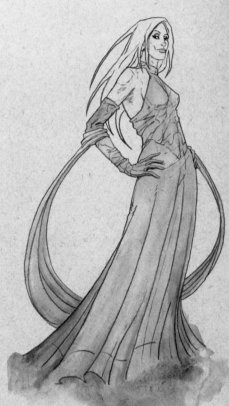

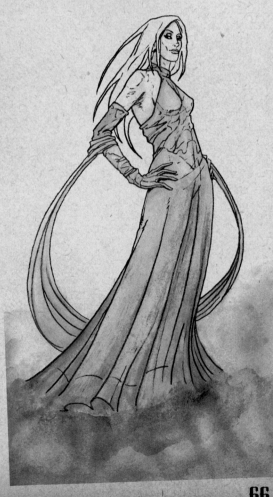

20 Now add more shadow and continue blending colours. The only major drawback with watercolours is that they don't always scan very well and some of the detail has been lost in this picture. You can also see where the paper has begun to warp at the bottom with the amount of water added. Using thicker watercolour paper is one way of avoiding this.

21 The hair was painted in Photoshop using a near black that still allowed some of the original detail to show through. The smoke effects were touched up using the Clone Stamp tool. It is not necessary to use Photoshop to finish such an illustration but the option is there if you want to continue to refine the image. If you are not using Photoshop you can fill in the hair with black watercolour or even use black Indian ink and a brush. You might also consider waiting for the whole painting to dry and then go over the lines with a black technical pen or brush and ink (as I did with the vampire on page 46).

Journey's End

Our trip to Norway has ended and hopefully you have a beautiful image to remember the visit. Art, like travel, isn't just about destination – sometimes the journey is more important. When working in any medium whether digital or paint you must decide whether you want to get it right first time or whether you want to explore, experiment and have fun. You should never be afraid to make mistakes and need to accept failure as part of the process of exploration. If you set out to create a perfect artwork every time you may be frustrated but if you just want to try things out, then you will be guaranteed to enjoy the process and learn a great deal while doing so.

NORGE

DRAGONS

Dragons appear in mythology worldwide but in English folklore they are serpentine creatures shown as fire-breathing and dinosaur-like, with wings, four legs and a long tail. Legends of dragons may have come from discoveries of fossilized dinosaur bones.

In England dragon tales can be found near dragon-consecrated churches, which abound in a line running across southern England from St Albans in the east to Glastonbury in the west. This 'serpent line' is the point at which the sun first strikes England on the dawn of the midsummer solstice and, from end to end, is the widest part of the country.

Dragons are often depicted as intelligent creatures who can talk and dragon's blood usually has magical properties. In Wagner's opera *Der Ring des Nibelungen*, the dragon gave the hero Siegmund the ability to understand bird language. The typical dragon protects a cave or castle filled with treasure and is often pitted against a hero, who tries to slay it. In French mythology a sorcerer-dragon called a Drac had the power of invisibility, while a Chinese dragon called Fucanglong caused volcanoes to erupt.

SCOTLAND

IRELAND

WALES

ENGLAND

EXPEDITION LOCATION: It's only a short trip across the North Sea to England now, a small country but a huge crossroads for so many cultures – Celtic, Nordic, Germanic and Roman, among others. This land is rich in myths and legends, replete with tales to inspire any artist – stories of warrior kings, fierce creatures, noble outlaws and stirring deeds.

EXPEDITION PREPARATION

- **TRAVEL GOALS:**
Learn how to use art board to create a mixed media image
Discover how to complete the artwork using digital tools in Photoshop

- **JOURNEY TIME:**
About two to four hours

- **EQUIPMENT:**
Pencils and eraser
Art board – 20 x 30cm (8 x 12in)
Gouache or acrylic paints – cheap set
Scanner, computer and Photoshop or Painter software

This mixed media picture of a mighty red dragon against a dark, storm-tossed sky has power and drama. This storm dragon has been modified to be closer to that of a classic English dragon, an archetypal creature in British folklore and known throughout most of Europe and the Middle East.

THE DRAGON

PENCIL WORK

Before you begin any new artwork it is best to immerse yourself in research to inspire and inform you, and then do a number of preparatory sketches. These can be simple doodles, like the image shown here, or complex studies where you will encounter all the major difficulties that the proposed artwork might present before committing to the final piece.

①

② After your preparatory sketches, begin by drawing the rough shape of a mountain and add a starburst of perspective lines directly above it to help define the curling shape of the creature. These perspective lines are just a rough guide. Draw a curling serpent shape that spirals around the convergence point of the perspective lines. Note how the underside is marked and how the spine curves back from the back of the skull. The basic skull shape is that of a snake. As you draw, thin the tail to a point and curl it around the mountain top – this will help to emphasize the creature's massive size.

③ Add the shape of the talons and the basic skeleton of the wings. The wings are roughly symmetrical and modelled on the construction of a bat's wings. Fill in the detail based on your preparatory sketches.

Colour work

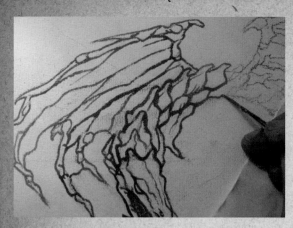

4 Begin the colour work by going over the pencil lines with a dark red or brown colour in gouache or acrylic. Mix colours to a medium consistency so they can be applied fluidly to the art board and yet still be strong enough to hold their line and not be too transparent. Apply a thin line that follows the pencil lines you have drawn. If the paint is too thick it will be hard to follow the line easily so make sure that it is smooth enough.

Create a circle of several complementary colours and mix each one into the next. This will give 5 you a wide variety of shades to work with. You won't use all the colours but will experiment a little and settle on certain mixes that you like the most. Each colour should be partly mixed into the next but don't mix both colours together entirely, leave some of each colour unmixed to allow you some variety in the shades.

6 When the dark line is dry add a base colour of mustard yellow using a fine brush. This colour should go up to and partly cover the dark line you have already laid down. It will also mix and blend with the pencil line underneath. In some places, this base colour will go over the dark line, which is fine – as you can see here the brown line is still visible beneath the yellow base colour.

While the mustard yellow is still wet, work 7 into it with a mixture of red and orange, working into the shadow areas of each section of the yellow. Don't do all the yellow at once but work in small sections so you can add the second colour while the first is still wet. Lay down a small area of yellow, work into it with red/orange then go to the next area of yellow.

8 Continue this process across the whole body. Use a fine brush and follow the lines so that extra texture is produced as it goes over the hard line underneath. Work on small sections at a time so that you can mix in a second colour while the first is still wet.

9 Follow through with the second colour – this can be a darker version of the previous colour. Apply this all over and particularly in areas where more depth and shadow is needed. Here it is used to bolster the hard line and add depth to the scales and spine. Whenever a second colour is mixed into the first it has the effect of creating form and depth, especially if the first colour is still slightly wet, allowing a more subtle blend with the second colour.

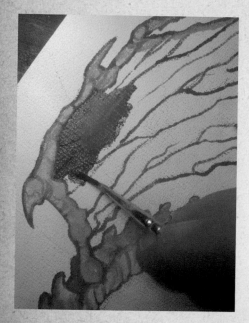

Here the base colour has been mixed with a second and third colour to add tone and variation in the colouring. You can also see how the pencil can get smudged when working on art board. Don't worry, this will either be covered by paint or removed in Photoshop. **10**

WINGS

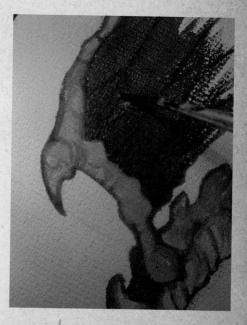

11 Apply this same process to the wings. Mix a strong red that will be complementary to the colours used on the body but slightly different to give some variation. Mix the paint so that it covers the dark line but is transparent enough for it to show through.

While the base colour on the wing is still wet use a deep brown to mix into the dark areas on the wings, giving them shape and volume. Work the dark brown outwards from the areas where there would be the most shadow, such as the area immediately next to the wing. Work the dark brown along the veins on the wing. **12**

Mountain

(13) Paint the mountain in a similar way with a mix of two colours – light grey and dark brown. You now have the final colour image. You can add further layers of shadow and highlights if you wish and can continue the process indefinitely depending on the size and quality of your canvas, paints and brushes. If working with a large canvas and high-quality paints and brushes you will be able to add much more detail than in this humble version. For the purposes of this exercise we will now move on to digital enhancements and see how some simple effects can be applied to such a painting.

Digital effects

(14) Once you have scanned your artwork into Photoshop (we are working on a small art board to make this possible), clean up the edges with the Eraser tool and delete any stray marks in the background. This is a good time to put the image through some filters to see what effects you get. Try out the Watercolor filter, which should result in an overall effect where the original grain of the art board can be seen. This can look quite good but could also be a disaster – it's a matter of opinion. Another option would be to try using the Smudge tool to blend all the colours. But let's leave that for now and see what else we can do.

Sky

(15) After scanning the image into your computer, find a good photo of a sky for the background. Any photo of clouds will work as you can darken them and put them through filters to make them look more dramatic.

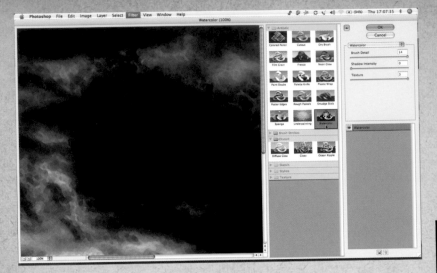

Use the Blur tool to soften the edges of the creature so the dragon blends with the background. Try experimenting with the Blur tool on a very low setting to soften various areas of the image. If you use it too much, the whole image will appear blurred so it's important to use it sparingly. **17**

16 The Filter Gallery in Photoshop contains many useful filters that can be used individually or in conjunction with each other to make the background match the dragon better. Remember, just using a filter isn't enough – you have to further modify images like this with the Smudge and Blur tools if you are really going to get the background to match the dragon and make it all convincing.

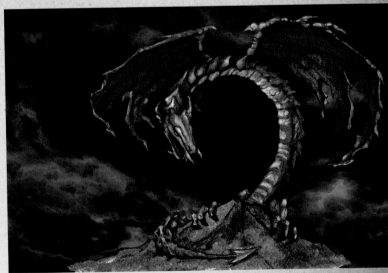

LIGHT AND DARK

18 Use the Dodge and Burn tools to deepen dark areas and lighten light areas. Go over the back of the spine, under the eyes, inside the mouth and along all areas that you darkened with colour mixes earlier.

19 Dodge and Burn should always be used on very low settings to begin with and then be built up with successive sweeps. You can see how the result can further enhance the dimension of the figure and give a stronger impression of volume.

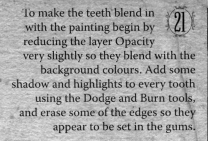

To make the teeth blend in with the painting begin by reducing the layer Opacity very slightly so they blend with the background colours. Add some shadow and highlights to every tooth using the Dodge and Burn tools, and erase some of the edges so they appear to be set in the gums. **21**

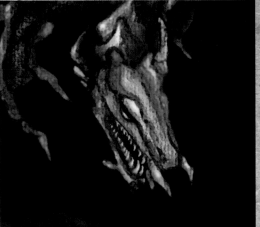

20 Paint in the white teeth on a new layer using the Brush tool. To begin with you will notice that they don't quite sit in with the picture yet.

Ideally, you should now go over the **22** whole image with the Smudge tool and subtly blend all the colours together to give it a sleek, painterly look but that would take another two or three hours and our time for this exercise is up.

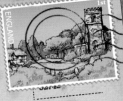

Journey's End

We bring home a fantastic image from this leg of the journey. Exquisite hyper-real depictions of fantasy art subjects such as this are often painted on large canvases and can take days, weeks or even months to complete. This method is complete within a few hours so it cannot compete with those masterpieces, however, the fundamental process is the same. It's just a matter of working larger, using more expensive equipment and working on each stage of the process for much, much longer ... Try this approach and see how it feels, if you like it, you know which direction to go in.

THE LELE

Female nature spirits can be found worldwide where there are forests or water. The Lele of Romania are typical of the type and are similar to the Scandinavian and Celtic elves and fairy peoples, being tall and beautiful, prone to dancing and capable of malevolence.

These spirits live in the sky as well as in remote forest and mountain regions and dance in tree tops and also at crossroads. Malevolent Lele can be warded off by wearing garlic or mugwort or by hanging the skull of a horse on a pole in front of the house. Their real names are secret and are usually replaced with symbols but personal names can be arranged in groups of nine by witches to form dangerous spells.

The hypnotic power of the fairy dance is well known and people who accidentally hear their songs become mute. Elves and fairies were said to have music so irresistible to humans that if a human attempted to play it he would be unable to stop and play himself to death … unless he could play it backwards and break the enchantment. Nature spirits are found worldwide, such as the sacred Divas and Elementals of Aboriginal Australia and marine spirits in Japan called Funayūrei, said to be the ghosts of people who have drowned at sea.

The archetypal fairy has appeared in art for centuries and for this image I used a classic look but was also inspired by photos of mannequins and puppets, which led to a creature that appeared to be more of a fairy/marionette hybrid and had a feel of Manga-style drawings.

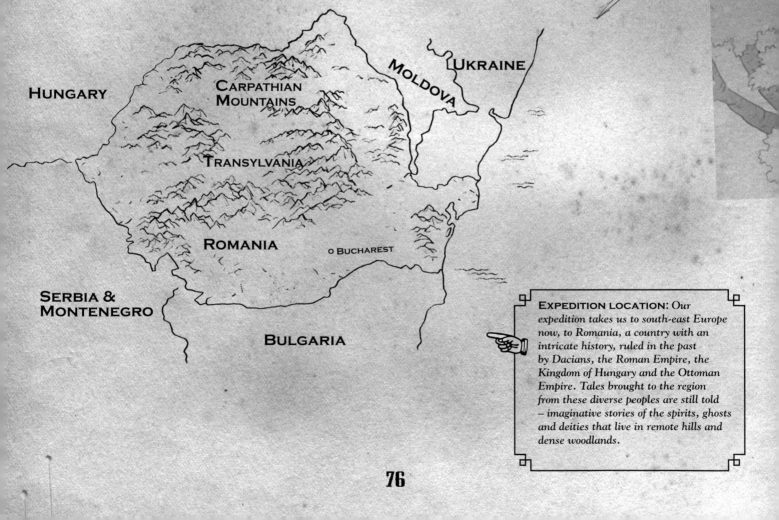

HUNGARY

CARPATHIAN MOUNTAINS

TRANSYLVANIA

MOLDOVA

UKRAINE

ROMANIA

o BUCHAREST

SERBIA & MONTENEGRO

BULGARIA

EXPEDITION LOCATION: *Our expedition takes us to south-east Europe now, to Romania, a country with an intricate history, ruled in the past by Dacians, the Roman Empire, the Kingdom of Hungary and the Ottoman Empire. Tales brought to the region from these diverse peoples are still told – imaginative stories of the spirits, ghosts and deities that live in remote hills and dense woodlands.*

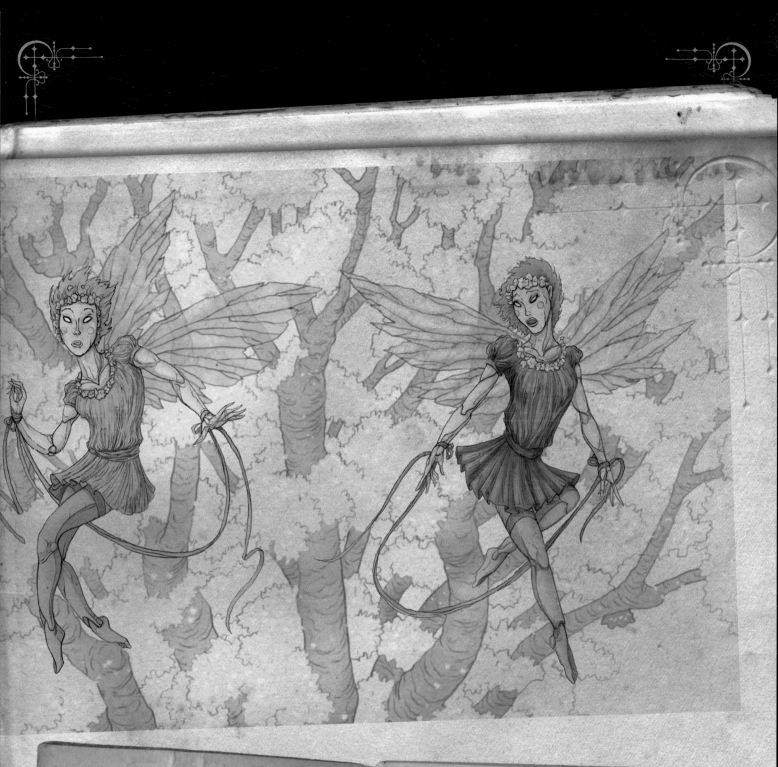

EXPEDITION PREPARATION

• TRAVEL GOALS:

Learn how to draw a female
figure with movement
Discover how drawings can
be coloured digitally using
a method that results in a
polished illustration with
clean lines and bold colours

• JOURNEY TIME:

About two to three hours

• EQUIPMENT:

Technical pencil and eraser
Light box (not essential)
Scanner, computer and
Photoshop or Painter
software

Expedition Discoveries

THE WILD PLACES OF THE WORLD ARE STILL HOME TO FAERIE SPIRITS AND OTHER FEY CREATURES. SOME OF THE FOLLOWING MAY REVEAL THEMSELVES TO YOU DURING THIS PART OF THE JOURNEY TO SOUTH-EAST EUROPE.

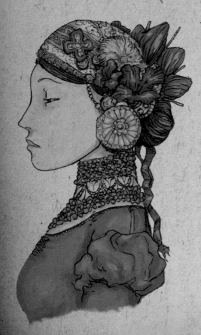

SÂNZIANA – The Sânziana are found in the Baneasa forest in Romania during the annual festival in their honour on 24 June. 'Sân' means 'saint' or 'holy' and 'zâna' means 'fairies'. During this ancient pagan celebration beautiful maidens dress in white and spend the day in the forest picking a flower called *Galium verum*, which they use to create floral crowns. By nightfall the girls become 'vessels' for the fairies and dance around a bonfire throwing the remains of the previous harvest into the flames, a symbol of giving back nature's gifts. No one speaks to or interrupts the girls during this ceremony so as not to anger the spirits that are working through them. Later, the local villagers push a burning wheel made from hay down a hill as a symbol for the setting sun. It is said that the heavens open on the festival of Sânziene and wishes can come true.

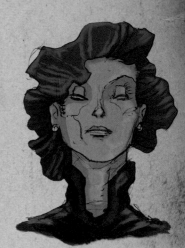

VÂLVA – The Vâlva are sisters to the Lele and if you are lucky you will only encounter the Vâlve Albe ('White Vâlve'), who can be found protecting a village from a raging storm. They appear first as shadows, which then take the form of black cats before transmuting into human form. In a war-ravaged region you may glimpse the Vâlve Negre ('Dark Vâlve') or the Vâlva Ciumei ('Vâlva of the Plague') who spread suffering and disease until placated with offerings.

WILA – In Poland and Lithuania the Wila are ghost-type female spirits said to be souls of the dead who visit the homes of their families. Like the Lele they can inhabit the sky as well as mountains, forest and lakes and they can also shape-shift into horses, falcons or swans. You can encounter the shape-shifting Wila in both Poland and Lithuania by searching for sacred trees, fairy caves and wells that had offerings of ribbons, round cakes, vegetables, fresh fruit or other flowers left around them by locals.

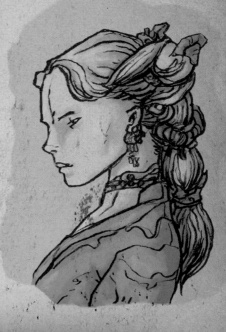

LAUMÉ – Only those who use magic are able to see these Lithuanian guardian spirits. They can be seen around young orphans and pregnant women for whom they weave a protective 'cloth of life'. The Laumé were once sky spirits but their compassion for humans brought them to earth to share our fate. There are three Laumé, like the Fates and the Norns, and they have birds' claws for feet just like the Russian Alkonost and the Greek Sirens.

PENCIL WORK

1 A figure in movement must have a certain amount of dynamic energy so begin by drawing fluid curving guide lines that express the movement of the limbs and the curve of the spine. Bear in mind that the pose of the character should already have been decided in preparatory sketches before beginning with these guide lines.

2 Construct the basic volumes for the body and head. Note that the fairy has a curvaceous shape and a very long neck. Work with curved shapes and keep the figure slim and lithe. Taper the shoulders to a thin waist and make the hips wide and round in shape. Aim to get the posture looking as spritely and agile as possible.

3 Work widthways around the limbs with a series of loose, spiralling lines, keeping these very light. Explore and experiment with the figure to see if you can 'find' the form rather than 'force' it. This method of spiralling around each limb and part of the body has the effect of discovering the volume and depth of the figure – literally giving the drawing 'body'. Pay attention to the shapes and positions of hands and feet, as these will enhance the movement in the expression of the character.

4 Now add the clothes. If you have a good anatomical shape to 'hang' the clothes on you will find that they naturally fall into place. The lines on the clothes generally flow downwards and the dress splays out slightly at the bottom, giving the impression of movement. The dress has a rounded neckline and little puffed Peter Pan sleeves. Sketch in the curving shape of the ribbon from wrist to wrist.

5 Now start to sharpen up the figure using a method of erasing/pencilling/erasing. Go over the areas of the image with a fine eraser then back in with pencil then back in with the eraser. Keep repeating this process to build up depth and detail. Work over the whole drawing in this way. Then go over the image to do a final pencil line. Draw the hair flowing in the wind to add to the general sense of movement. The trailing ends of the ribbons attached to the figure's wrists are roughly symmetrical in their composition, which gives the effect of 'framing' the figure. Add more detail to these ribbons at this stage.

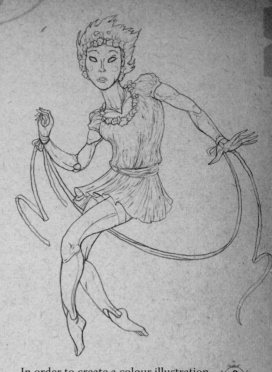

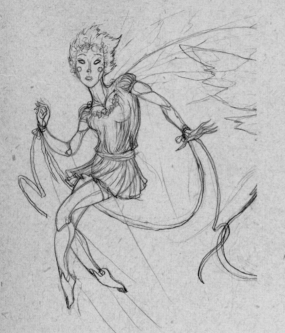

6 In order to create a colour illustration with the clean, sharp style of a Manga or comic book it may be necessary to use a light box and trace off a clean line version of the figure on to smooth paper using a hard pencil. If you don't use a light box use an eraser to thoroughly clean up the original.

WINGS

7 Draw the wings on a separate piece of paper in order to make it easier to colour them once they are in the computer. As they are scanned separately they can simply be copied on to a separate layer in Photoshop. The wings can be drawn quite simply with a pattern of veining branching out from their bases.

DIGITAL COLOURING

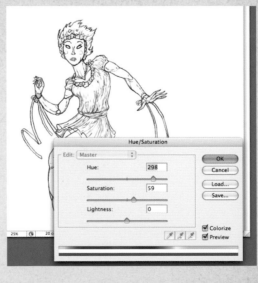

8 Scan the image and open it in Photoshop and then use the Hue/ Saturation dialog box to Colorize the pencil line. This has the effect of matching the drawing nicely with the colours you are about to add.

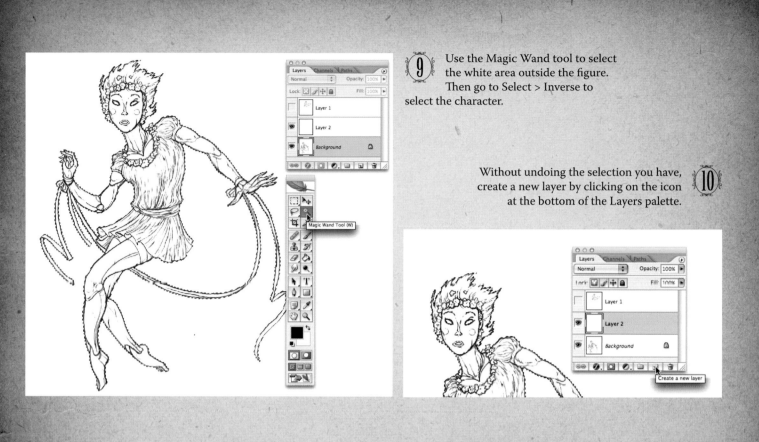

9 Use the Magic Wand tool to select the white area outside the figure. Then go to Select > Inverse to select the character.

10 Without undoing the selection you have, create a new layer by clicking on the icon at the bottom of the Layers palette.

11 Select Multiply from the layer properties pull-down list at the top of the Layers palette. This means that your new layer will be transparent so that anything you add on this layer will be see through.

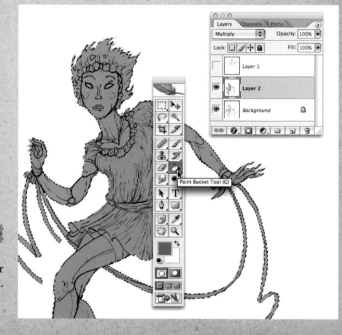

12 Select the Paint Bucket tool and choose a a pale amber colour. Click within the selected area of the figure and it will dump your chosen colour into the area selected.

13 Now begin making slight colour variations on the figure. Use the Lasso tool to select different areas one at a time and then use the Hue/Saturation dialog box to vary the colours slightly. Don't vary the colours too much but keep them within a narrow tonal range. This process can take time and be painstaking as you will need to vary the colour on the skin, clothes, ribbons, eyes and mouth.

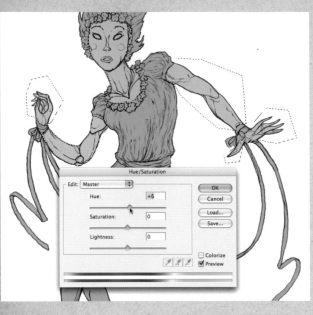

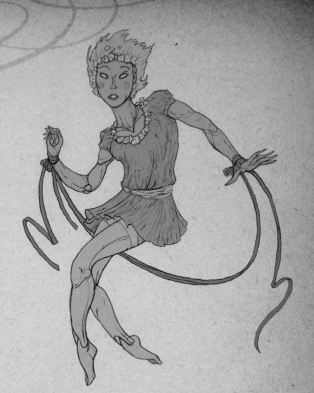

14 Here is the result of slightly varying the colour of all the elements of the figure. You may need to go back and forth changing each element in order to get an overall balance. Experiment, play around and see what works for you. Save each selection as you go to make experimentation easier.

Shadow layer

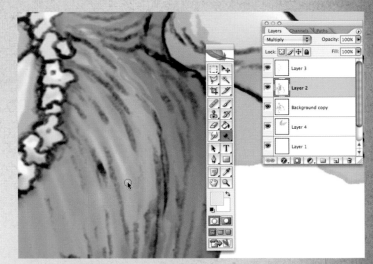

15 Now add a new layer and produce a shadow layer (see also page 24). Remember that the shadow layer must be placed on a new layer and it must also be a Multiply layer. If you find it is too dark, reduce the opacity of the whole layer using the Opacity control on the Layers palette.

16 A shadow layer consists of a single flat colour so now build up depth and tonal variety to these shadows using the Dodge and Burn tools. Begin with a wide brush on a very low setting and work on the general shadow areas. Gradually use smaller brushes as you work shadow and highlights into every crease and fold of clothing, as well as body details such as beneath the fingers and each muscle. This process leads to greater definition of all aspects of the figure and means creating shadows within shadows and highlights within highlights.

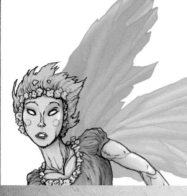

17 Create the colour on the wings using the same process as the figure – by dumping colour on to a new layer and then carefully working in with the Dodge and Burn tools. In order to create the translucent effect of fairy wings you can use the Gaussian Blur dialog box, which can be found in the Filter pull-down menu under Blur.

The result is a polished illustration with slick colouring and clean lines – the type of thing you might find in a graphic novel or animation. **18**

Journey's End

Our time among the nature spirits in Romania has been well spent and has resulted in an image of great delicacy and movement. Whether you are working digitally or with paint you will find yourself developing the same skills: you are always working with shadow and light to create depth and texture, and you are always searching for a good colour balance. No matter what medium you choose to work in you will find that repetition and experimentation will eventually lead to you developing an instinct for your medium and you will gradually work more quickly and more effectively as you do so.

SCREAMERS

Screaming women spirits appear in Spanish, French and South American folklore and are common in countries with Celtic traditions, particularly Scotland, Ireland and Wales.

The Irish Banshee is a spirit who appears howling and wailing at funerals or more ominously, before a death is about to occur. These spirits are spread throughout the counties and islands of Ireland, Scotland and Wales and have many other counterparts with whom they share similarities, such as the Scottish Leanan Sídhe, which comes from the Gaelic word 'leannan' meaning a 'sweetheart' or 'favourite'. These creatures offer inspiration to artists in exchange for success and fame but the contract usually results in the madness or death of the artist. These spirits are only visible to artists and they are known to protect them, like many other muses throughout history. They offer an impossible, unobtainable love greater than any mortal woman, which drives the artist to great achievements but drains the life from him, much like a vampire. The Candileja is a vicious old female spirit from Columbian folklore who is damned to travel the world surrounded by flames.

SCOTLAND

ENGLAND

IRELAND

EXPEDITION LOCATION: We travel north now to the deep lochs and heather-clad mountains of Scotland. This country of beautiful islands and highlands has a rich Celtic history spanning thousands of years. Artists will find it a rewarding location, with an extensive heritage of myths and legends and strong beliefs in the world of elves and fairies, strange sea creatures, second sight and haunted castles.

EXPEDITION PREPARATION

• **TRAVEL GOALS:**

Learn how to construct a human face, perhaps the most difficult subject of all Discover the basic principles of painting from dark to light on a canvas-type surface such as art board

• **JOURNEY TIME:**

About four to five hours

• **EQUIPMENT:**

Pencil and eraser
Gouache paints – cheap set
Brushes – at least two good fine ones and a thicker one
Art board – 20 x 30cm (8 x 12in)

The creature known as Leanan Sídhe was a type of Banshee beloved of artists and poets, who fell in love with her in return for her gifts of creativity and success. For that reason it seems obvious that the character should have a dark beauty. The artists who fell for her would invariably die as a result of their pact so it makes sense that she must not only be beautiful but also have a deadly cast to her features. The original drawing of the Leanan shown left was based on a friend of mine who is a great admirer of Gothic art and poetry and seemed to fit the bill very well.

Expedition Discoveries

CELTIC FOLKLORE IS RICH WITH STORIES ABOUT POWERFUL AND PERSISTENT FEMALE SPIRITS, MANY OF WHICH HAVE COUNTERPARTS IN OTHER CULTURES THROUGHOUT THE WORLD. THESE BEINGS, SOMETIMES BENIGN, OFTEN MALEVOLENT, ALL HAVE LOCAL VARIATIONS IN APPEARANCE AND PERSONALITY.

THE CAILLEACHAN – In Scotland, the Cailleachan are also known as The Storm Hags and are personifications of the destructive powers of nature. They appear during spring time when they cause storms during the period known as A' Chailleach. The Cailleachan turn to stone on the ancient pagan festival of Beltane and change back to human form on Samhain in time to rule over the winter months. The Cailleachan brings in winter by washing her plaid cloth in the Whirlpool of Coire Bhreacain and the roar of the coming tempest can be heard 20 miles away. When she has finished, her plaid is white and winter has arrived, with snow covering the land.

WILI – In Serbia the Wili gather at crossroads at midnight to dance. These female vampires are unable to rest in their graves because they could not satisfy their passion for dancing when they were alive. As dawn breaks they disappear back into their nocturnal slumber.

CAOINTEACH – This creature is a Banshee, also known as Caoineag, and inhabits the western highlands of Argyll in Scotland. She wears a green shawl and is heard wailing in the night before a death or catastrophe within the clan to which she is attached. Her name means 'the weeper' and she is similar to the Bean Nighe, the Washer at the Ford, but, unlike the Bean Nighe, she cannot be seen or grant wishes. It was said that before the Massacre of Glencoe (the massacre of the Macdonalds by the Campbells in 1692) the Caoineag of the Macdonalds was heard wailing for several nights.

BASIC CONSTRUCTION

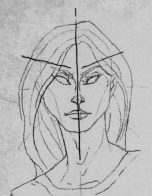

① Let's begin by seeing exactly how the face should be drawn. Using a fine pencil, start with the standard crossed lines. For this image the brow lines point downwards, as this will contribute towards the figure looking as if she is frowning or at least appearing slightly demonic. These sketches show the outline of the head and hair but yours will build up in stages, as denoted by the darker lines.

② Add a squashed oval for the cranium. This shouldn't be a perfect circle but should refer to the perspective of the face, so try to imagine it as a solid object rather than a flat shape.

③ Add the jawline and cheekbones. In the case of Leanan the jaw should be relatively long as she has bold features. Be careful not to make the chin either too pointy or too wide. Draw the cheekbones last, and in this case they just offer a little definition.

FACIAL FEATURES

④ Draw in some circles for the eyes close to the bottom of the cranium; draw whole circles as these provide the shape around which you will 'wrap' the eyelids and is a much easier technique for getting the shape of the eyes correct. Draw the nose with a diamond shape at the top: this is just the guide line – the whole shape will not be kept. At this stage the mouth consists of a single straight line. Add basic construction lines for the ears.

⑤ For the eyes, imagine that the circles are spheres and warp the upper eyelid around them. Add more detail to the nose, two small flecks for the nostrils and a nib over the top. Change the line of the mouth from a straight line and give it a dip in the middle, add some small flecks at either end for the corners of the mouth, to give more personality.

⑥ Add the lower eyelids and go back over the shape of the eyes a few times to thicken them up. Add the upper eyelids. Draw in the upper and lower lips and sketch in the eyebrows which should follow the line of the eyes.

Hair

⑦ Begin the hairline with the front part. Imagine two long tresses, one on each side, with one tucked behind an ear. This character has a fairly thick volume of hair rather than lots of wispy strands so the lines flow straight down and are fairly well spaced apart.

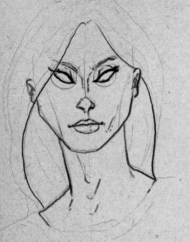

⑧ Match the back line of the hair to the front except that it is thicker at the top, tapering towards the front lines at the bottom. This gives the impression that the front bunches of hair are excluding the back, thus giving an impression of volume.

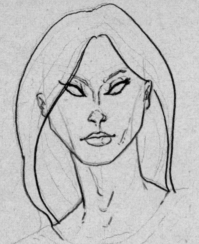

⑨ Use flowing lines, working from top to bottom to match the front and back lines of the hair. It is not necessary to add lots of detail or thicken up your pencil lines at this stage. This is going to be a painting so all you need are guide lines.

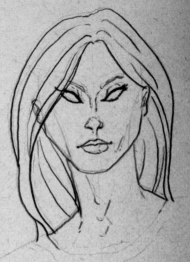

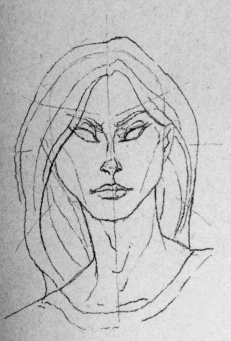

⑩ You can see here how the original drawing appears on art board. There is no shadow added at this stage. All the shadow, tone and texture will be added with successive layers of paint so none of the original pencil lines will be visible in the finished painting. For this image only a small amount of the character's garment will show, so just draw a rounded neckline on the dress.

Painting

⑪ When experimenting with painting you can get by with cheap canvas and paints but cheap brushes just don't do the job (see page 12 for advice on brushes). Begin by mixing up sufficient quantities of three colours, blue, mauve and dark blue/purple – think in terms of light, medium and dark. Make sure the colours are well mixed and of a good medium consistency so they flow effortlessly off the brush. It is important that the mix is not too thick and not too thin, so aim for a smooth, creamy consistency. Start with small quantities of paint to ensure you get the colour you prefer and do some tests on a separate canvas or art paper to see how they dry.

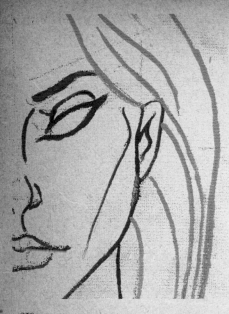

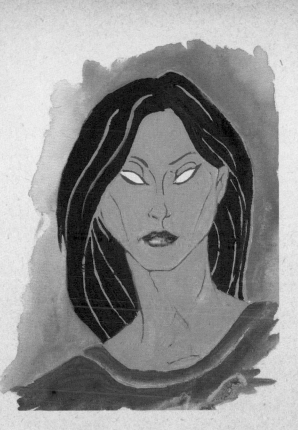

13 Once the basic lines are almost dry, lay down the base colours using a thicker brush – dark blue/purple for the hair, mauve for the skin and blue for the dress. Work carefully up to the lines that you laid down in the previous step. It doesn't matter if you go over the line here and there as in the long run they will be fully blended in. For the background use a wetter mix of paint, which will result in more variation in colour and produce more texture.

12 Begin by painting along the basic pencil lines using a fine brush. On areas that will be dark, in this case the hair, use a light colour. On areas that will be light, such as the face, use a dark colour such as the blue here. This technique is a matter of 'drawing' with the brush so rotate the canvas to ensure that the thickness of the line is correct and each line tapers off in the right place. Do some test lines on a separate piece of paper whenever you dip your brush in the paint.

SHADOW LAYER

Now add a shadow layer. This should be a slightly wetter **14** version of the base colour. The wetter colour appears lighter but dries almost imperceptibly darker, as you can see in the area of hair behind the neck. The comparative wetness will bring the base colour back to life and the two will start to mix together, creating blends. Continue to work these areas into each other by going over and over with the brush to mix them into the colour underneath.

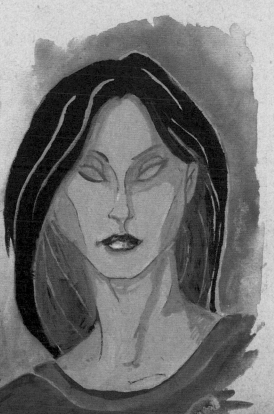

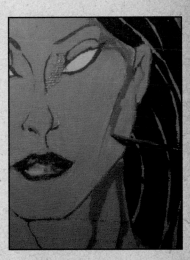

When adding shadow begin with the most **15** obvious areas such as the hairline, the jawline, the eye sockets and the cheekbones. Use a slightly wetter mix of paint for these initial shadow areas – as the paint dries it will fade into the background colour. Start at the place where the shadow will be darkest and work outwards. You may need to go over these shadow areas several times.

Highlights

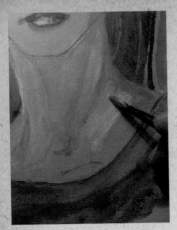

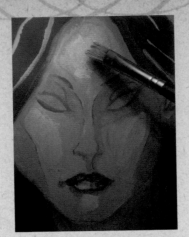

(16) Now begin to add highlights. Look at other paintings or photographs to see where you would normally add highlights. Add some white to the mauve base colour to lighten it and add a small amount of water to make it slightly wetter so it blends well. The paint will stay wet for a while and you will have plenty of time to blend the colours so do not panic if the highlight looks clumsy at first – work the paint in over a period of time and allow the depth of paint to build up gradually.

(17) Most of the front areas of the face should now be lightened and you can use a thicker brush for this or work with a fine brush if it feels more comfortable. You can see here how much it stands out at first but don't worry because you will be gradually building up several layers of light/dark/light and blending the colours as you go along.

Continue working on blending in light colours and then start to add (18) darker colours. For the eyes and hairline use a finer brush and add much darker lines, to make them stand out. In general though, don't make the next layer of shadows too dark or they will obliterate the highlights as you blend them together.
Put the darkest brush aside and swap between your light brush and your medium dark brush, gradually building and blending your shadow and light areas.

Blending and balance

(19) At this stage you will be working on the whole painting, jumping about from area to area adding light and dark, trying to keep the whole thing in balance and blending and smoothing the colours into each other as you go. Here you can see I have moved back to the darkest brush to build up the dark area along the neckline.

Areas such as the lips and eyes require the (21) most detail. Work into them with dark purple around the edges that fades into white highlights (added last). Tighten the outline with a very fine, almost black, line.

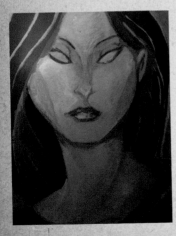

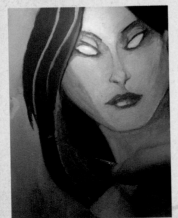

(20) Continue with the dark brush – see how the purple of the hair is now almost entirely black but the original pale purple painted over the pencil line has been blended in to create some highlights in the hair below the left ear.

22 On the cheekbones you can still see the original dark blue line that was painted over the pencil line, still visible through the pale purple base colour. Above it you can see where the white highlight was added and beneath where the shadow was added. All the colours have been gradually blended together on the art board by the use of repeated brushstrokes running along the direction of the cheekbone.

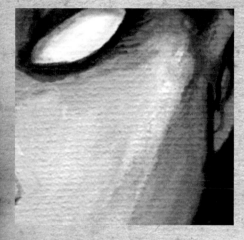

23 Build up the dress detail by first painting some patterns with black and going over them with highlights. They were left quite rough here but you could continue working into them and blending them together in the same way you did on the features and hair.

The main advantage of working with gouache, acrylics or oils is that you can push them around on the canvas while they dry. Oils take the longest **24** to dry and allow you to work with them over longer periods of time, while gouache can be brought back to life after it has almost completely dried.

Journey's End

The wailing women encountered in Scotland have made good models for learning how to render a face. In all the methods we have looked at, the hardest thing is maintaining a balance of tone and colour. The advantage with paint is that it can be blended but if you go too far the whole thing will end up being muddy. Nevertheless, this is an outcome you must be prepared to accept if you are going to explore and experiment. You will often find that you should have stopped earlier and a perfectly good painting has been ruined. Don't lose heart – making mistakes is an important part of the learning process and will prepare you far better for your next attempt.

Scotland
1st
02142

THE DJINN

In English the word 'genie' derives from the Latin word *'genius'*, a type of guardian spirit thought to be assigned to each person at their birth.

The French translators of *The Book of One Thousand and One Nights* used 'genie' as a translation of *'jinni'* because it was similar to the Arabic word in sound and in meaning. The Arabic root *'jnn'* means 'concealment' and 'remoteness'. Djinn or jinn are said to be creatures with free will and there is evidence in the Qur'an that the Devil was not an angel but a djinn. Egyptian superstition holds that angels are made of light, djinn are made of subtle fire and man is made of earth.

Other types of djinn include the Ghul or 'night shade', which can shape shift, and the Sila, which cannot shape shift. Djinn are aerial animals with transparent bodies that can assume various forms and may at first show themselves as pillars of dust. It is said that they inhabit the lower heavens and so hear the conversations of angels …

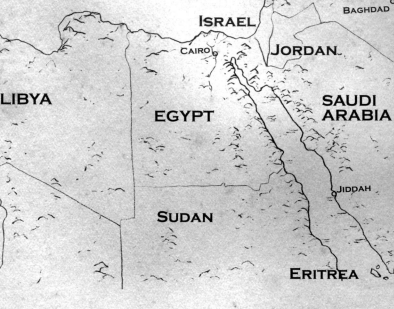

EXPEDITION LOCATION: *We travel far to the south now, to the dazzling heat and history of Egypt. The Middle East is often seen as the cradle of civilization with mythical traditions dating back to the earliest human cultures. The geography of the vast inhospitable deserts has given rise to creatures inspired by sandstorms and mirages. The necessity for traders and explorers to travel huge distances through dangerous territories has resulted in legends of kingdoms, peoples and creatures lost in time in the desert sands.*

EXPEDITION PREPARATION

- **TRAVEL GOALS:**

 Discover how to paint anatomical figures

 Learn how to use gouache or acrylics to create detailed line work in a small painting on Bristol board

- **JOURNEY TIME:**

 About three hours

- **EQUIPMENT:**

 Pencil and erasers – 0.9mm HB propelling pencil or a normal 2B pencil

 Bristol board – 180gsm (80lbs)

 Gouache or acrylic paints

 Brushes – various sizes from 000 to thick

 Light box (optional)

 During the early 1900s illustrators such as Arthur Rackham, Edmund Dulac and Kay Nielsen became famous for their depictions of fairy tales and the exciting tales from *The Book of One Thousand and One Nights*. Their styles varied but they are all recognizable by their use of strong, colourful lines, a style that provided the inspiration for the classic djinn archetype portrayed here in vibrant gouache. There are various types of djinn: the pair portrayed here are called Grine, said to be doppelgängers, doubles of human beings that exist in a parallel dimension. They appear to their human counterpart either as a warning or as a kind of demon that possesses them.

FACE

This sketch shows the basic structure for the figure ① emerging from the oil lamp. Note that the figure has a massively broad torso tapering towards the smoke and has a roughly inverted triangular shape. The main thing to consider is that this figure will be very muscular and strong so it also has a thick neck and massive jaw. Draw these construction lines to suggest that we will be looking slightly upwards at the figure.

As you draw the head, the skull should be pointed at the top and broad at ② the cheekbones before narrowing to a large, flat jaw. Make the line of the mouth comparatively simple and cartoon like. This type of drawing is highly stylized, leaning towards comic or animation illustration, so you can afford to exaggerate the features. Begin with light, loose lines to define your shapes and then work towards fine, strong lines where you can press harder as opposed to using soft tones.

③ Draw the eyes as semicircles that emerge from under the heavy brow line. Form the nose as a large triangle with a broad base. These sorts of features are typical of the image of the djinn that has entered into popular culture and the look has become an archetype.

Add eyebrows above the brow line. The high, ④ arched brow that slants downwards gives the eyes a distinctively oriental quality. Eyebrows are used to emphasize expressions, so try a variety of different eyebrow shapes to see how this affects the overall impression of the character. Add some full, thick lips that stretch almost entirely across the face.

5 Make the ears quite pointed at the top, as befits a demon. When drawing the hair it should fit close to the skull but then flow out in a thick tress tied with a band. Add some earrings too. Decide just how much you want to exaggerate each feature; some artists prefer to take it to the extreme while others stay closer to realistic proportions. Draw a ponytail suspended in the air, not hanging down, as this will suggest a breeze and add movement to an otherwise static image. Strengthen the key lines around the jaw and face.

Now go back over all your lines and darken them. The object of this exercise is to produce a painting with strong, tight lines. This process is almost impossible to teach as it requires hundreds of minute, almost imperceptible variations to the pencil line that gradually agglomerate into the final image – go at your own pace and be your own judge. **6**

Expedition Discoveries

CAIRO IS ONE OF THE OLDEST CITIES ON EARTH – A SEETHING LABYRINTH OF VIBRANT LIFE WHERE ALL THE ERAS OF HISTORY SEEM TO MEET IN THE PRESENT MOMENT. THIS IS THE CITY OF *THE BOOK OF ONE THOUSAND AND ONE NIGHTS* – THE ETERNAL OCEAN OF STORIES SAID TO HAVE TAKEN COUNTLESS MEN 1,000 YEARS TO WRITE. THIS COLLECTION OF FOLK STORIES, FROM A DOZEN COUNTRIES DATING BACK TO 8TH-CENTURY INDIA, WERE PASSED ON BY TRAVELLERS AND MERCHANTS TO PERSIA, FINALLY REACHING EGYPT AT THE END OF THE 15TH CENTURY WHEN THE FIRST COMPILATION WAS MADE. THE BOOK IS FULL OF STORIES WITHIN STORIES, INCLUDING ALADDIN'S WONDERFUL LAMP, ALI BABA AND THE FORTY THIEVES AND THE SEVEN VOYAGES OF SINBAD THE SAILOR. ALL OF THE STORIES ARE CONTAINED WITHIN A VAST CENTRAL TALE OF THE SULTAN SHAHRYAR, WHO HAS BEEN DECEIVED BY HIS WIFE AND WHO, IN ORDER NEVER TO BE DECEIVED AGAIN, RESOLVES TO MARRY EVERY NIGHT AND KILL THE WOMAN THE FOLLOWING MORNING. THE HEROINE OF THE STORY, THE SULTAN'S LATEST WIFE SCHEHERÁZADE, STAYS ALIVE BY TELLING STORIES THAT HAVE NO END. SHE AND THE SULTAN SPEND A THOUSAND AND ONE NIGHTS TOGETHER AND BY THE END SHE HAS GIVEN BIRTH TO A SON AND THE SULTAN HAS CHANGED HIS WAYS.

Torso and arms

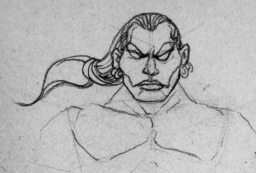

⑦ Draw the torso so that it is massive and broad. Begin with a huge pyramid-shaped neck that matches the shape of the head. You can find plenty of useful references to outrageous muscular physiques by looking at images of bodybuilders, but try to keep muscular detail to a minimum in line with the traditional style of the illustration. Add some outline detail to the neck and pectoral muscles; these are quite angular and simplistic, in keeping with the overall comic book-style of the illustration.

The classic pose for a djinn is to have the arms folded, so draw the forearms massively over proportioned, with the fingers of the left hand tucked in. There isn't much action in this composition; the djinn has a non-aggressive pose and appears impassive but threatening nonetheless. Begin by using flowing, curving lines applied loosely and lightly in pencil. When you are satisfied with the shape and proportions thicken and strengthen the lines and make them slightly more angular and sharper, as opposed to curving and flowing. ⑧

⑨ Now work into the torso area with plenty of musculature, particularly the abdominals. Add extra muscles to the forearms and lines branching out from the centre of the chest. Be sure to add a bold outline to the figure. Build up muscles by drawing the basic shapes then adding muscles on top of muscles on top of muscles – it's not anatomically correct but it contributes to the overall look.

At this point even though the musculature is complete you now need to erase a lot of the construction lines and clear some space for the jewellery around the neck, upper arm and wrist. This process of adding and taking away is typical of all drawing work. If you are unhappy about erasing your efforts use a light box or tracing paper to make a new version on which you can add further detail. ⑩

(11) Draw the jewellery by following the curves of the neck, biceps and wrists and build up a series of bracelets with plenty of detail. Draw the jewellery from the front so each jewel appears slightly behind the last, which gives a better impression of volume. Draw some guide lines first to help define the way that necklaces hang. Make sure the bracelets' edges curve to match the shape of the body parts they are adorning.

Create the smoke with long flowing lines (12) starting at the top where it meets the torso. The lines should overlap and fold into each other. You can spend hours working on smoke but the trick is to let your pencil find its own course. It may take a few tries but don't force it – let your hand wander and the lines will find their own way.

Allow some of your lines to twist (13) across from the top to the bottom of the smoke to create the impression of depth. This twisting and curving is essential to add volume and there are several different ways of doing it. In this case, just use simple lines that overlap and intertwine. Other artists might use broken-up lines or lots of tiny dots to express the intangible, shifting quality of smoke. Look at how other artists working in pencil or ink have done similar things.

(14) Once you have the basic shape of the smoke add a few more lines for extra detail and make some of these lines wavy at the ends. How you express elements like smoke and water is one of those things that becomes part of your individual style and evolves with time.

(15) The final addition is the lamp at the bottom. Draw it in profile and very flat with little volume – this execution is in keeping with this kind of illustrative style. The whole drawing should have strong, consistent lines so be prepared to go over it all again to strengthen your pencil lines.

It's not entirely necessary but it is good idea to trace off the final image on to a sheet of clean Bristol board. This will give you a nice clean image to paint on to. You can see here how the lines have no tone around them, and again, this is a choice made by the individual – there is no right or wrong way of doing it. (16)

Base colour

The base colour for the djinn should be a flesh tone but a (17) dark and tawny one. Begin with white and add a tiny amount of red to get a pale pink, then mix in tiny amounts of green until you get the correct colour. Be sure to test it on a separate sheet of Bristol board and wait until it has dried to see what the colour ends up as. The consistency should be such that it lays down a good strong base but you can still see the pencil lines through it. If the base colour is too dark it may cause problems when you want to add shadow, but if it is too light the figure will appear too pale. See also page 14 for tips on mixing paint.

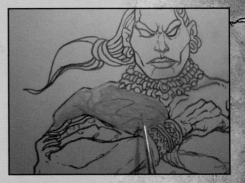

Work very carefully up to (18) the outside lines making sure you don't go over them and ensure that the whole area is adequately covered. The colour will pick up some tone from the pencil line; this is fine as it will add to the overall tone, providing that it blends well. Don't add too much paint at once – build up the thickness of the paint as you go along.

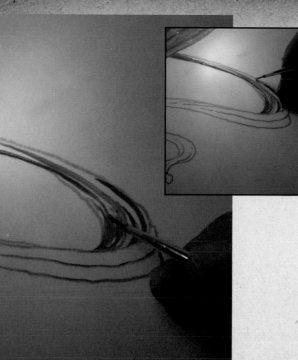

20 Mix some yellow and, while the red is still wet, paint in the yellow. Keep drawing your brush in the same direction as the lines of the smoke to blend the two colours together. You can only do this in one small section of the smoke at a time as you need to work while the paint is still wet. Always try to work in the direction of the lines of the drawing as this helps to build volume.

19 Now work on the smoke. Begin with a strong red colour and paint in some lines that follow the curves of the smoke. They don't have to be perfectly accurate because you are about to blend them with another colour. It is important to work quite fast here and use small amounts of paint so that your brush keeps a very fine tip.

21 The final base colour is still quite pale but all the main elements are covered except for the jewellery. With canvas and art board you can add successive layers of paint and keep building up the light and dark areas. However, Bristol board isn't strong enough to do that because it is just card and there is a limit to how much paint it will take, so it is important to keep colours quite flat and be gentle with your brush.

22 Now colour the jewellery. Begin by painting it all with a base colour of yellow so that it matches the overall look of the image. Then add a complementary colour that is not too different but not too similar to the rest – in this case green. Add the final details in orange. Add more detail to the hair as well as colouring the eyes, lips and fingernails.

Line and Shadow

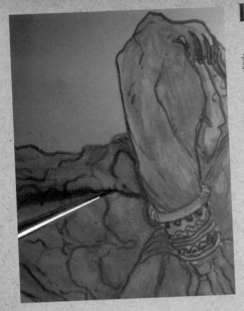

23 At this stage the various elements of the djinn still contrast strongly with each other. Now is the time to bring the whole lot together with a single colour that will unify everything. This colour, a dark brown, will do two things; it will strengthen all the pencil lines and will also build up shadow. Start by going around all the areas of skin and muscles by following the pencil lines.

Go over the whole torso adding depth of colour then gradually 24 draw the brown down into the smoke area, following the lines first to blend the two together. You can add tiny amounts of water to the board in order to help fade out the dark brown but keep it to a minimum as adding water can quickly damage the flat colour underneath.

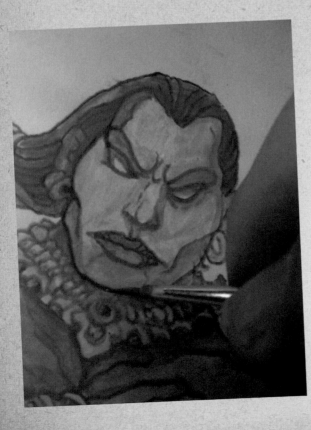

25 Using a fine brush, carefully go over every single pencil line in the drawing. In some areas, such as the jawline, you will need to go over the same line several times. This process can continue for a long time as you gradually build up darker shadows and strengthen all the lines, which will bring the image together into a cohesive whole.

26 Here is the final painted version with the dark lines and shadows complete. Compare this to the finished base colour version (see step 21, page 99) and you will see how much stronger it has become, all thanks to the addition of the dark brown line and shadow. When the painting is almost dry you could add highlights with a much lighter colour, which will result in more volume. This was not done here though, in order to retain the feel of a fairly flat image.

Finally, scan the painted image into Photoshop and try a filter on it. In this **27** case Diffuse Glow was applied, which creates a glowing look that is suitable for a djinn. Feel free to experiment at this stage.

Journey's End

Our visit to magical Egypt is drawing to a close but some valuable lessons have been learned on this part of the expedition. As you will have seen by this exercise, paintings will very often look crude right up until the last stage, which is often the longest. But stick with it as this final stage of blending and strengthening is the point at which all the elements of the image are brought together as one. Yet again, we see that the method of creating this type of art in any medium is a constant process of striving to find the right balance of all the elements.

THE VAMPIRE PLAGUE

Forget all the vampires encountered up until now – the African Vampire plagues are an entirely different species. When they rise up to feed they massacre entire towns, moving through countries like a plague of locusts leaving nothing left alive.

These immense plagues feed only once every 10 to 20 years, after which they hibernate. No one has *ever* survived an encounter with them. World governments have known of their existence for centuries but they are powerless to stop them so they do their best to cover up their existence with tales of war and famine. When it comes to dealing with these rapacious creatures the best preparation you can have is a very fast means of escape. Garlic, crosses and stakes won't work, so write your last will and testament and say farewell to your loved ones.

AFRICA

SOUTH ATLANTIC OCEAN

MADAGASGAR

EXPEDITION LOCATION: *Africa is next on our itinerary, the birthplace of mankind, a vast and varied continent that is home to so many cultures. Many of Africa's diverse myths and legends arose from the continent's geographical settings, climatic conditions and colourful history. Many deal with the origin of the world and the fate of individuals after death, such as vampire and zombie stories.*

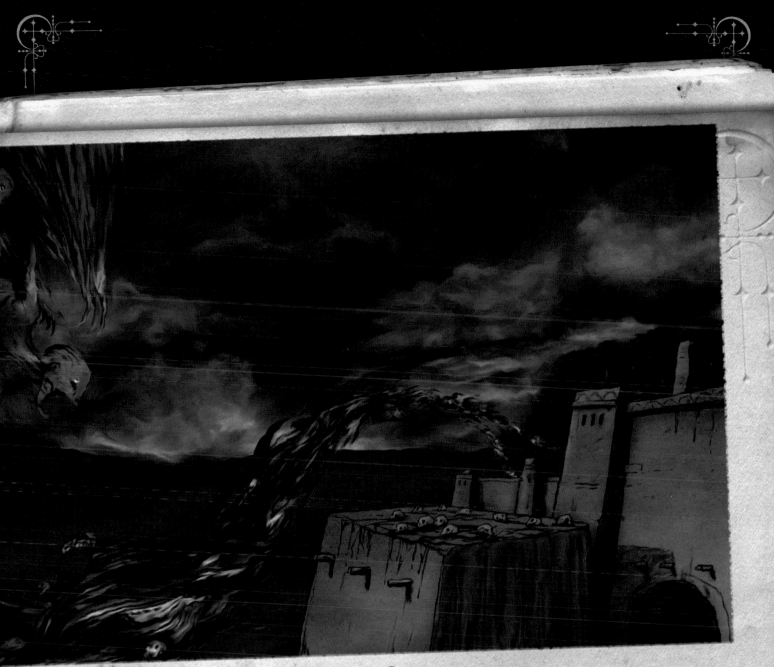

 The idea of a plague of primitive vampire creatures did not come from any previous references to vampires that I had seen. The idea came instead from looking at the world history of plagues and massacres from ancient times to the present day and led to this swarm-like image, with vampires erupting from a ravaged city.

EXPEDITION PREPARATION

• TRAVEL GOALS:

Learn how to use a pencil drawing in combination with sampled textures in Photoshop to give a head start with digital painting Discover a little about the art of using smudging and blending in Photoshop to achieve a painterly effect

• JOURNEY TIME:

About six to twelve hours

• EQUIPMENT:

Pencil and eraser
Several sheets of paper
Light box
Scanner, computer and
Photoshop software

Compositional Work

① The basic composition of this illustration is very important – a great sweep of vampires pouring out of a city beneath a stormy desert sky. All illustrations that have an 'epic' quality should begin with a very simple composition like this. Study classical art to see how other painters have 'staged' their scenes. Begin by making a pencil sketch like this and work on a light box to trace it off for the next stage.

A useful trick when drawing large groups of beings is to start by placing some key figures spread either throughout the group or in dominant positions so as to draw the eye towards them when the piece is finished. Structure the image by drawing the two main vampires and then add a few more tailing them before going on to fill in the gaps with swirly lines, wing shapes and the shadows of other vampires. ②

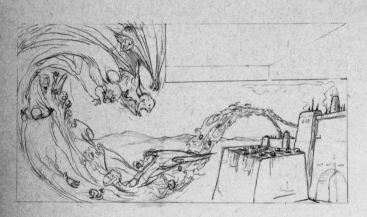

③ Add detail to your main vampires, in particular facial features and hands, as these creatures will have to stand out. Start to define some basic shapes for the other vampires. The aim here is to give the impression of a large number of creatures without having to draw every one. The eye will be drawn towards the dominant figures in the group. Sketch in the buildings at this stage.

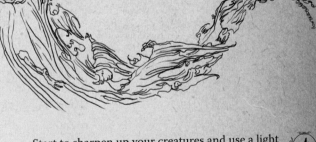

Start to sharpen up your creatures and use a light box if possible to trace them off on to a fresh sheet of paper. No shadow has been added yet, although this will play a very important part. For this reason you should consider just how much detail you need to put in, finding a balance between too much unnecessary detail and too little. ④

SHADOW

5 Start adding shadow, the crucial element that will give the impression of a large crowd. As you draw, allow your main characters to stand out by having less shadow and more detail but have the others recede into a mass of dark shapes. As you build up shadow allow your pencil lines to flow in the direction of the spiral – remember your original compositional drawing and follow these lines.

6 Scan this final pencil image into Photoshop and significantly darken it using the Curves dialog, which will turn the grey pencil lines to black.
Draw the background, the buildings and mountains on separate pieces of paper on the light box, using the original rough sketch as a guide. Scan these separately to make it easier to colour them later. Draw the mountains using a simple technique of overlapping outlines rising from the horizon, followed by some sparse details of simple lines flowing outwards from the peaks.

SAMPLING TEXTURES

7 Now you need to overlay the vampires with a texture before you start 'painting' them. This texture came from a sky photograph, put through some filters to produce a painted effect. Any texture can be used and manipulated and sky images can be used for all sorts of things other than skies, as we shall see now.

8 Copy the texture you have chosen on to a new Multiply layer above your scanned drawing. When you copy an item into a new document like this, it automatically appears on a new layer, so all you have to do is choose Multiply from the layer properties menu at the top of the Layers palette. Now, use the Transform function to re-size the texture to cover the whole area of your vampires.

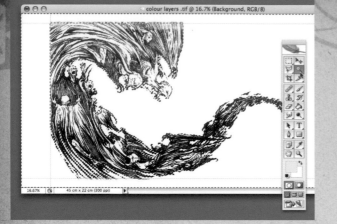

9 Now go to your vampire layer (the layer with the texture on has been made invisible here) and use the Magic Wand tool to select the area outside the vampires.

10 Now select your texture layer and press the delete button. This deletes everything around the area of your vampires so you end up with a vampire horde-shaped piece of texture.

When you see it as a Multiply layer it is uncanny how well the texture **11** can match your drawing, despite the fact that it started off as a picture of some clouds. You can use any number of textures in this way to kick start the process of colouring your figures to make them look more like paintings.

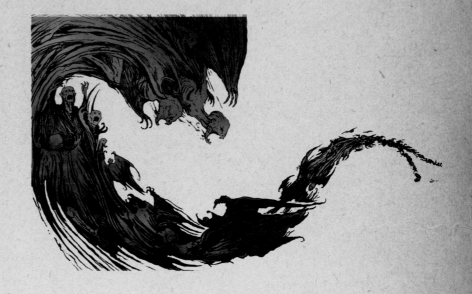

DODGE AND BURN

You now have to use various tools now to get the texture to match your vampires **12** and turn the whole thing into a cohesive painting. Begin with the Dodge and Burn tools. Just overlaying texture is never enough – you need to manually modify the textures to match the shapes and details of your original drawing. The Dodge and Burn tools are shown in the palette here.

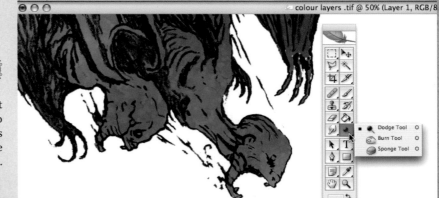

(13) Dodging will lighten areas so think about the shape of your vampires and where the light will fall on them. This process will brighten areas so they begin to have a more three-dimensional quality. You can adjust the strength of the Dodge and Burn tools so start off with a very low setting of 3% or 4% and build it up gradually. Think in terms of the areas that might be highlighted, such as the leading edges of faces and limbs.

Toggle to Burn by holding down the Control key and begin to work on the shadow areas, using the same process of gradually darkening them. Again, use a low setting and build up the shadow gradually. Work around the eyes, behind the ears, in the mouth, behind the skull – anywhere that will have some shadow on it. Continue across the whole of the artwork. (14)

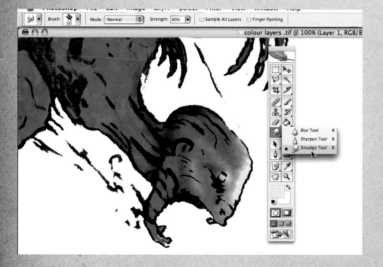

SMUDGE

(15) The Smudge tool (in a sub-menu beneath the Blur tool) will really help to make the texture follow the lines of your vampire drawing and give it a more painterly effect. Using this tool is where the real creative challenge begins as you will have to carefully blend and mix the colours on your texture layer to match the figures and you will need to vary the strength of the smudge according to what suits the painting best. Keep zooming out to view your work from a distance so you can judge the overall look and adjust your technique as you go along.

(16) Use the Smudge tool to blend the textured area into the shapes of the vampires. You can see here how it can create a variety of brush stroke effects and you can push the colours around indefinitely. This process can take hours to complete as the more you do it, the better it will look. Surprisingly, you can also learn a great deal about traditional painting techniques by doing this. Needless to say, this process takes time to learn and lots of practice – keep spare copies of your work as you go along so you can return to them if you find you are making too many mistakes.

When the whole texture layer has been painstakingly dodged and smudged it could look something like this. You can see clearly where the shadows have been added and how the smudging has pulled the colours around to match the shape of the vampires. (17)

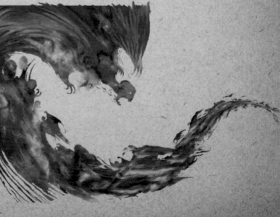

Blending

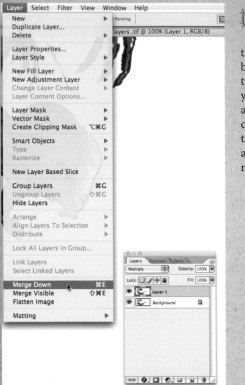

18 You now need to blend the pencil line with the texture layer. Begin by merging the layers together. You could save your layered document and make a new flat copy to work on in case things don't go too well at the next stage. You may want to start again.

19 With the texture layer and pencil layer now on one flat layer you can return to the smudge tool and begin to blend the pencil lines into the colour over the whole image. This can have a great effect as you refine the pencil lines, soften them and create an elegant and detailed mix.

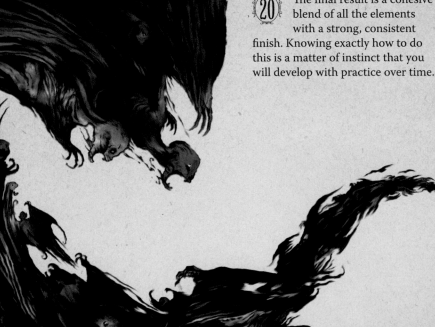

20 The final result is a cohesive blend of all the elements with a strong, consistent finish. Knowing exactly how to do this is a matter of instinct that you will develop with practice over time.

Sky and other elements

21 Now apply the same process to all the other elements. Piece the sky together by copying and pasting sky and cloud textures. Cover gaps up by using the Rubber Stamp tool. The whole thing can then be put through yet more filters. To make the sky convincing, go over the whole thing with the Smudge tool to create brushstrokes and thus interesting new patterns and shapes.

Use the same method with the buildings. **22** The texture here began as a scan of an oil painting of a desert scene. The more you work on a texture, the more depth and variety it will have.

As with the vampires, place the texture on a separate layer and use the Dodge and **23** Burn tools to add shadow and highlights. The Smudge tool wasn't used here as it would have obliterated the speckled texture of the original source material. Now merge the textured layer with the pencil layer before using some judicious smudging to blend the whole lot together. The final smudging is a delicate process – an instinct that you will develop with practice. Turn back to pages 102 103 to see the final result.

Journey's End

This stage of our journey to an epic country like Africa has resulted in an equally epic image. Using sample textures is a great way to provide a good base to work on top of but there is no escaping the manual work needed to make an image truly convincing. Many of the basic techniques in this book are meant to provide short-cuts and quick solutions but there are some things that just can't be done quickly. When it comes to painting it is always best to take your time.

THE DENIZENS OF CLINTON ROAD

There are some places in the world where you can feel the supernatural all around you ... it is as if the membrane that divides us is somehow thinner, making it easier to cross over to the shadowside. Clinton Road is one such place.

Clinton Road is in Passaic County, New Jersey and the area is rife with stories of paranormal occurrences – from witches' Sabbaths to spectral teenage girls driving ghost Camaros. Crossroads in general have long been a place where fairy folk or supernatural beings could be encountered. Such places became synonymous with meeting the devil, who came to represent all supernatural creatures. A crossroads has a strong metaphorical meaning as a place where a choice is made. Sacred trees, watering holes, and the many spirits associated with them, could also be found at crossroads.

Near Clinton Road is the abandoned community of New City Village, commonly known as Demon's Alley. There is no official record as to why the community was left abandoned. Local legend says that a devil worshipper moved into the community and lured all of his neighbours to his home where his cult members massacred them all.

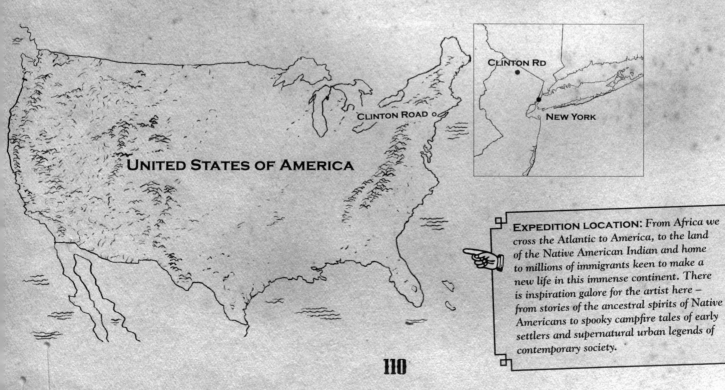

UNITED STATES OF AMERICA

CLINTON ROAD ○

CLINTON RD

NEW YORK

EXPEDITION LOCATION: From Africa we cross the Atlantic to America, to the land of the Native American Indian and home to millions of immigrants keen to make a new life in this immense continent. There is inspiration galore for the artist here – from stories of the ancestral spirits of Native Americans to spooky campfire tales of early settlers and supernatural urban legends of contemporary society.

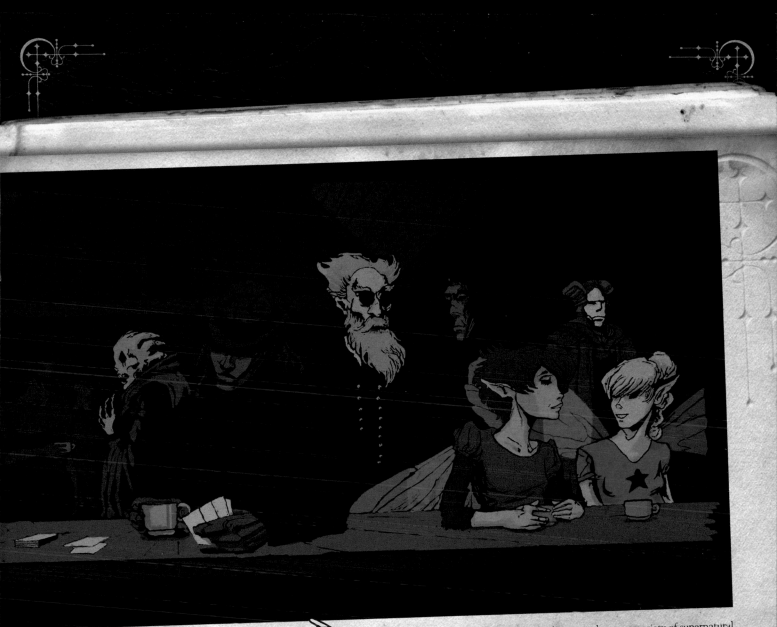

When I learned that the Clinton Road area was host to a variety of supernatural occurrences, I wondered if it was a kind of 'crossroads of the supernatural'. I imagined that these creatures might have a supernatural café or bar where they would hang out – and that idea was the inspiration for this image. The blue demon shown in the sequence overleaf struck me as amusing: he would be fearsome to look at but was a regular guy who would show up to have a cappuccino and read a good book.

EXPEDITION PREPARATION

• TRAVEL GOALS:

Discover how to draw
a convincing demon
Learn to work out of a black
background into colour
to produce an effect not
unlike an old woodcut

• EQUIPMENT:

Pencils and eraser
Paper – any type will do
Scanner, computer and
Photoshop software

• JOURNEY TIME:

About one to two hours

Expedition Discoveries

Clinton Road seems to be a magnet for creepy supernatural occurrences. Here are just a few of the strange and disturbing sights you might see during your journey through Passaic County, USA.

DEAD MAN'S BRIDGE – At Dead Man's Bridge on Clinton Road the ghost of a boy who drowned there has been seen in broad daylight. It is said that if you throw a coin into the water it will be thrown back out to you by the ghost. Some witnesses say the boy pushed them out of the water to save their lives.

HELLHOUNDS – Strange creatures such as hellhounds and unidentifiable monsters crossing the road at night have been caught in the glare of car headlights. One story tells of a hellhound with glowing eyes bounding out of the foliage and chasing terrified carloads of people down the road at incredibly high speeds.

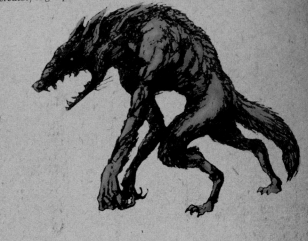

CROSS CASTLE – Cross Castle was built in 1905 by Richard Cross on high land near Clinton Road but in the late 20th century it fell into ruin after a fire destroyed part of it. Wall markings in inaccessible positions on the castle's interior were said to have been for satanic rituals. Visitors there have claimed to have had seizures or suffered attacks by invisible beings.

THE RIDER – In American hoodoo culture the man who meets people at the crossroads and teaches them skills is sometimes called the devil but is also known as 'the rider' and the 'li'l ole funny boy'. This phenomenon seems to be descended from a number of African crossroads spirits such as Legba, Ellegua and Pomba Gira. The myth is known in popular American culture through the story told in the 1930s by blues singer Robert Johnson, who claimed he had learned how to play guitar by selling his soul to the devil at the crossroads. In truth it was another blues singer, Robert's friend Tommy Johnson, who made this claim.

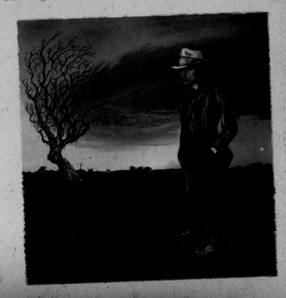

BLUE DEMON

PENCIL WORK

① The basic framework should consist of a bent-over spine with a short torso region and stocky legs planted firmly. So using your normal drawing pencil, sketch some perspective lines that show that the horizon line at waist level, so we are looking up at the top half of the character but down at the bottom half. Add other lines to denote the general positions of the feet, knees and wings.

② Draw the basic volumes of the figure, in particular the muscle groups of the arms, chest and legs. Make the calves as big as the thighs. The head should be very low and jutt forwards, with spine visible above it. The fact that the chest and stomach bow inwards and then curve out towards the thighs is all important to the personality of the character. The wings are mere suggestions at this stage.

③ Break up the basic shapes by working into the muscles with a series of curving lines. Make the eyebrows very pronounced and the mouth very large with a huge lower lip. When constructing a figure from volumes in this way there is a tendency for characters to become monotonous. Work extra hard therefore to break up the simple forms and add detail to make every aspect of the character more interesting. Add more detail to the wings, particularly the bony supports and also sketch in the basic shape of the cup in his hand.

④ Now start to put in much looser detail. The eyes are looking directly towards us, which helps us to engage with the 'friendly' personality of this figure. Continue to add details such as the folds of the trousers, the turned-up bottoms, the belt, cloven hooves and more detail on musculature and suggestions of body hair. Keep your pencil lines loose, allowing your pencil to move freely and explore the shape of the character.

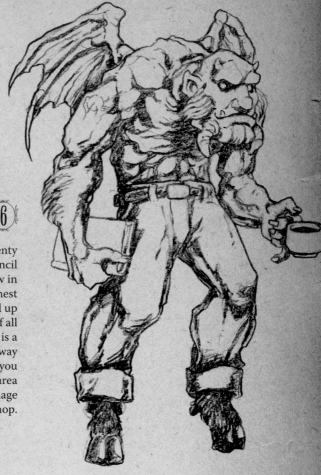

⑤ Draw the book in the left hand and add more detail to the hooves, hands and face. Clean up the drawing carefully with an eraser before doing the final pencil lines. Make the outer line very strong by going over it several times with the pencil.

⑥ Unlike the Lele (see page 76), which required clean lines for a certain look, this character will need plenty of shadow added at the pencil stage. Work a lot of shadow in around the eyes and on the chest and then methodically build up shadow down the sides of all the limbs. Be sure that there is a strong unbroken line all the way around the figure otherwise you won't be able to select the area around it when you get the image into Photoshop.

DIGITAL COLOURING

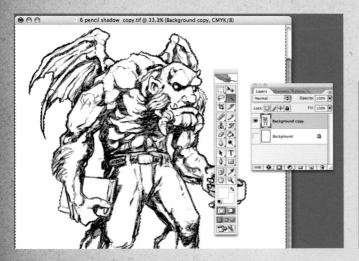

⑦ Scan your pencil drawing into Photoshop and clean it up with the Eraser tool. Duplicate the layer and delete the original background layer. Now you have to make a space around it to add a black background. Use the Magic Wand tool to select the area around the figure and delete it on the same layer that the artwork itself is on.

⑧ Still using the Magic Wand tool, uncheck the Contiguous button at the top of the toolbar and select any area of white inside the demon. This will result in all the white areas of the demon being selected at once.

⑨ Make a new layer without losing the selection and use the Paint Bucket tool to dump a strong blue colour on to it. This means that you will have an area of colour for everything that *isn't* a pencil line. Make sure this is on a new layer and not the layer with the actual drawing on it.

Go to the empty background layer and use the Paint Bucket tool to fill it with black. Switch off the little eye button next to your pencil layer and this is what you will see. From now on you will no longer be using the original pencil scan in this image. All you have now is the layer with the colour on it and the fully black background layer. ⑩

CREATING VARIETY

⑪ Now you can create some variety in the different elements of the demon. Working on the colour layer (the blue), use the Lasso tool to select different aspects of the creature one at a time and use the Hue/Saturation dialog box to adjust the colours. Do this with the wings, trousers, fingernails, sideburns and so on until there is a slight colour variation in all the different elements of him and his clothing. Use the Brush tool to drop some white into the eyes.

The image shown here is what you will end up with. All the blacks are completely consistent as they are all from the background layer. The colours are completely flat with just a little variation. Now it's time to add depth by adding some shadow and highlights. ⑫

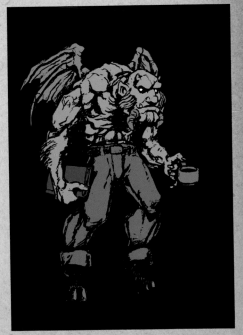

Shadow

⟨13⟩ Use the Brush tool to create a shadow layer on a new layer. With a stark and bold drawing like this, the shadow layer can have a very powerful effect, adding drama to the overall look. Make a new layer and make sure it is a Multiply layer by selecting Multiply from the pull-down menu at the top of the Layers palette. Use the Brush tool to add a very pale grey colour on all the shadow areas of the drawing.

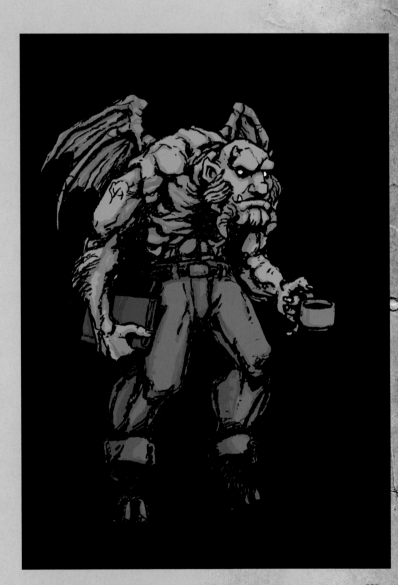

⟨14⟩ When you have done this the complete shadow layer will look like the image here. Work along the lines of the original pencil shadow but also extend well beyond them to create new areas of shadow. Use the Eraser tool to correct any mistakes as you go. If desired, lighten the whole layer using the Opacity control on the Layers palette or even change the colour entirely using the Hue/Saturation dialog box.

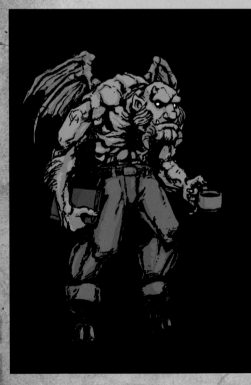

You can add a second layer of shadow on a new layer on top of the first. It's not very obvious at first but can add a new ⟨15⟩ dimension. Minor changes like these can be very subtle but used to great effect. The two layers of shadow can work together to create interesting shapes and patterns within the shadow areas.

Highlights

16 At this stage you can add basic highlights in white with the Brush tool on a new layer. They do not need to adhere strictly to the rules of where light would land but should be fairly consistent in the way they are placed. Use these highlights very sparingly – they will stick out a great deal at first, but don't worry because you can adjust this in the next step.

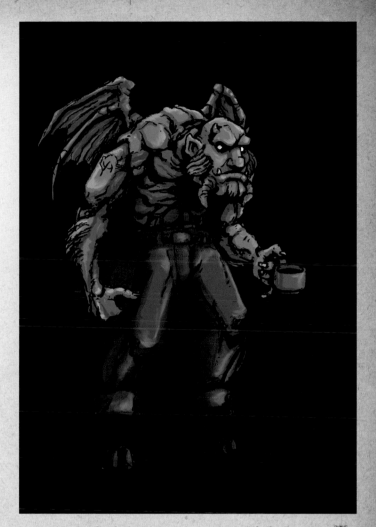

17 Now fade the highlights using the Opacity control on the Layers palette – you will find that you can reduce them until they are almost invisible but they will still be effective. Use the Smudge tool to soften them a little and smooth them so that they follow the shape of the figure better.

To finish the image, play around with the Levels to make the whole thing much darker. Fill in some of the areas of black using the Brush tool to make the image look a bit neater – this is a matter of personal judgement, a skill that you will develop over time. **18**

Journey's End

Our sojourn in America is over but we have this impressive demon from Clinton Road as a souvenir. You could spend more time experimenting with a non-digital image, so rather than use a computer and Photoshop you can achieve a similar look with coloured inks, which are designed to give flat areas of colour. The Tintin books were all coloured in this way. However, if you do use this ink method you must add the black last and only after you have given the colours time to dry completely otherwise the black will bleed into the colours.

THE WILD HUNT

The Wild Hunt, a horde of ecstatic wolf warriors in pursuit of prey, has appeared throughout history in many countries. Humans were swept up by it and carried to the land of the dead or were rewarded with gold if they joined the hunt.

The prey of the hunt could be a mythical boar, kidnapped maidens or wood nymphs. Depending on the country, every version of the hunt had a different leader: Diana the huntress in the Mediterranean; King Valdemar in Denmark; Frau Hold in Switzerland and the great Norse god Odin in the north. The hunt has its origins in several beliefs including Diana the Roman goddess of hunting and the pursuit of the Erymanthian boar in Greek mythology. In Germany it is believed to descend from warrior cults such as the Harii who painted themselves black to attack their enemies at night. The wild hunt story can also be found in English folklore, where the hunt appears in Windsor Great Park. The Swedish island of Gotland is one location where the hunt has been witnessed regularly.

The rampaging Wild Hunt makes a great subject for a fantasy art image, as shown here in this digitally coloured image. The leader of the hunt can be anyone you choose but it seems fitting that we should finish this book by drawing one of the most famous mythological characters – the great Norse god Odin. I looked at dozens of renditions of this hero and was particularly inspired by one old-fashioned illustration of him with his cloak flapping in the wind behind him. This gave rise to the composition that I started with. The stepped sequence overleaf shows how to draw Odin himself.

NORWEGIAN SEA

NORWAY

LAPLAND

SWEDEN

GULF OF BOTHNIA

FINLAND

O HELSINKI

O TALLINN

O OSLO

O STOCKHOLM

ESTONIA

O RIGA

LATVIA

BALTIC SEA

DENMARK
COPENHAGEN O

LITHUANIA
VILNIUS O

EXPEDITION LOCATION: The final leg of our journey takes us to Sweden, a country richly influenced by Celtic, Nordic, Slavic and Germanic cultures. Many of Sweden's myths and traditions go back to Viking days, when men roved the seas in exploration and fought battles to please their gods. Stories were told as entertainment through the long, cold winter nights – tales of gods battling fierce trolls, of witches flying across the horizon, of sprites cavorting through the night and dwarves mining mountains for gold and gems.

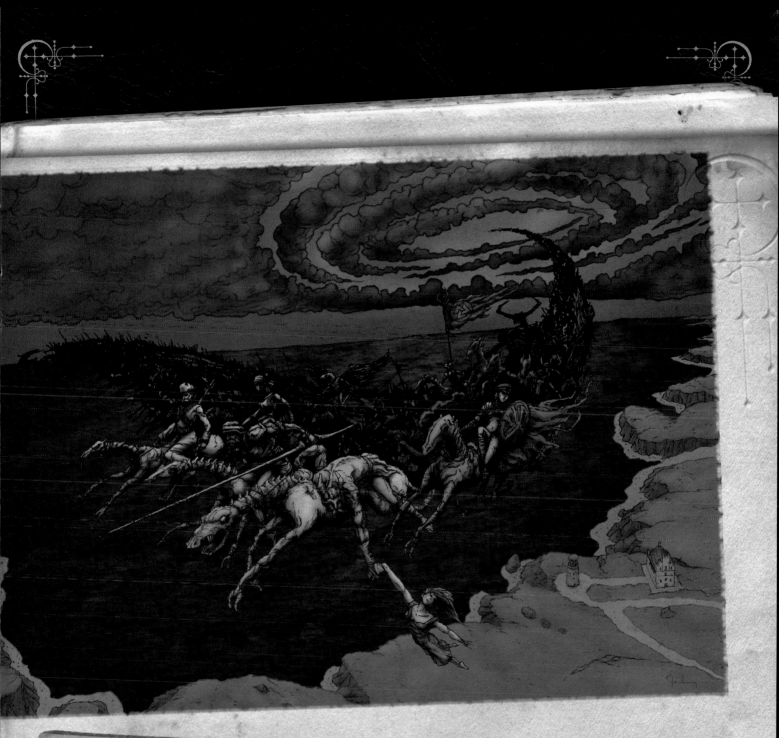

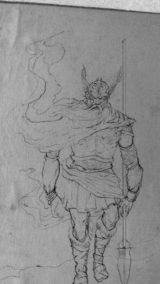

EXPEDITION PREPARATION

• TRAVEL GOALS:

Discover how to produce
an image using just pencil
and paper
Improve your pencil skills
and undertake a complex
line illustration

• EQUIPMENT:

Pencil and eraser
Paper of any sort – no trace-
offs or light box are needed
as all the work will be done
on a single sheet

• JOURNEY TIME:

About three hours

PREPARATORY STUDIES

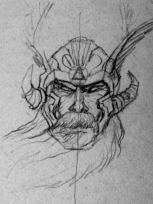

① It is in the nature of myth and fantasy that sooner or later you must attempt an illustration of epic proportions. So begin with a few studies, such as the two sketches shown here, and use these to work out the precise details of the armour and headdress. This will save a lot of bother later on when you are working on the final drawing. Allow yourself plenty of time to collect research from different sources, designing characters and embellishing the ideas that you have discovered during your studies.

COMPOSITIONAL WORK

② The composition of this figure is based on a very central perspective so begin by drawing a cross with lines radiating from it in a sunburst pattern. Rough in the basic body parts. Give him broad shoulders and a wide, strong neck. Have the head tilting slightly downwards and the arms curving slightly inwards. In the final image the left hand will be holding a long spear. Using flat volumes like these will eventually hinder your artistic style but don't worry, as your skills develop you will rely on these less and be able to plunge straight into more elaborate compositions and anatomy without too much preparation.

CAPE

④ Draw the outer folds of the cape first, the part across the front of his body. An old illustration of Odin inspired the shape of this cloak – having it whipping off in the wind behind him added drama and balanced out the composition in an interesting way.

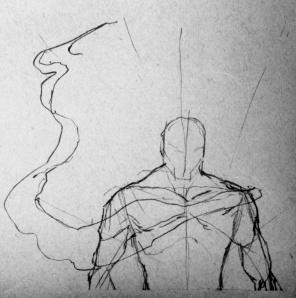

③ Begin to work in the details of his musculature; much of this will be covered by clothing and armour but it will show through his clothes and add realism to your image. Make sure the left hand is a shape that can be modified later to grasp the spear. Use your pencil lines to 'sculpt' the shapes of the muscles. Keep the lines light and loose to begin with and don't press too hard yet.

5 Now draw the inside folds of the cape. There is the beginnings of a 'hollow' in the cape as it unfolds behind him – this is important to the overall impact so you may have to try it a few times to achieve that three-dimensional effect (jump ahead briefly to the finished image on page 126 to see the final effect).

Boots

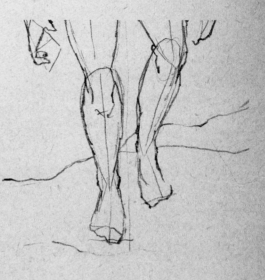

Draw the lower legs so that the feet point away from each other slightly and the back foot appears above and behind the front foot – this gives the impression that the figure is stepping forwards, so the back leg is bent more at the knee than the front leg. Feet can be as tricky as hands to draw but you should have a pair of your own to use as reference! **6**

7 The boots comprise leather bands wrapped around a fur interior, which pokes out at the top. Begin by drawing diagonal lines that appear to wrap around the shape of the calves and feet. You can see here that the straps appear to be wrapped too tight – a mistake that beginners often make.

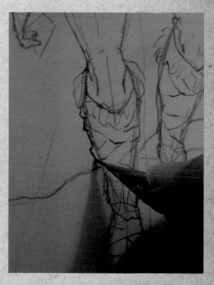

Draw an outline of the boots that matches the leather straps. Make sure that you work *outside* the original line of the leg to give more volume to the straps. This rule applies to all clothing but you should vary your line according to the type of material you are trying to depict. The materials worn on the legs are not hard like wood or metal so use soft, loose strokes. **8**

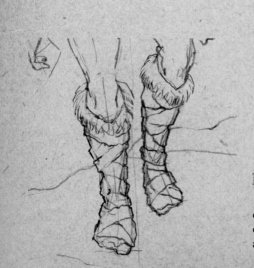

9 You can see here how the outline enhances the impression of the leather straps being solid, giving them substance. Over time you should build up your own personal 'library' of pencil techniques that you can employ for different materials and finishes. You will also find it helpful to look at the work of other artists as the differences between rendering various types of materials with a pencil can be very subtle.

Armour

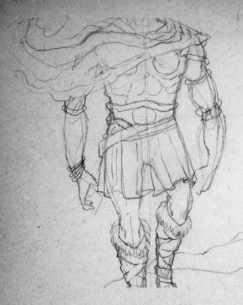

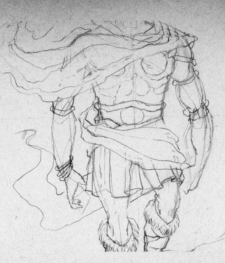

10 Build up the armour with general shapes that follow the lines of the body but go beyond the original outline. Draw the tunic or kilt to show folds in the material. Add armbands, bracelets, body armour and belts. Just add the basic shapes for now to see how it looks before adding further detail but think ahead about exactly what kind of details you might want to add, such as rivets, eyelets, chainmail, twine, laces and so on.

11 Erase some of the kilt area and draw in the basic lines of the second cloak. This cloak is important because it creates a compositional counterpoint to the first cloak. The two cloaks flow around the body in a spiralling fashion, which also helps to give great movement and a dynamic quality to the final image.

12 Use a fine eraser to clean up inside the areas of the armour. As you do this you will be able to see clearly whether the armour sits well on the figure or not. If it looks clumsy, erase it all and start again. You may find you need to 'sculpt' your pencil lines over and over until you achieve the right look. Keep sitting back and viewing your work as a whole to check that each element is sitting well within the composition. Squinting your eyes can also help.

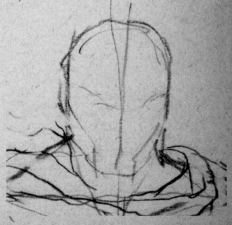

13 Now add some detail to the armour. I used sharp geometric designs inspired by the shape of Nordic runes rather than the more curvy Celtic shapes commonly used in illustrations of this type. The logo compromising three triangles on his belt is based on the Triskelion, an ancient symbol long associated with Odin. Build up the fabric around the exposed areas of flesh on the arms and legs and draw this fabric bunching up where it meets the armour.

Face and helmet

14 Draw the face so that it is broad with a strong jawline and a flat, wide chin, sketching in some preliminary guide lines. This character is based on fairly realistic proportions so there is no need to exaggerate any particular part such as the jaw, which you might consider doing with other fantasy characters such as a djinn or dwarf.

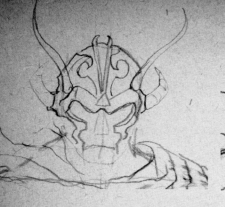

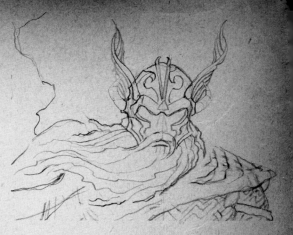

Draw the basic nose shape and the outline of the helmet, **15** which can be copied from the studies you prepared earlier. Items such as helmets require design so you should try a few different versions separately before working on the final drawing. Odin was originally depicted with a wide-brimmed hat but this gave way to the archetypal horned helmet in 19th-century depictions.

Draw in the details of the helmet. These will be a slight **16** improvement on your studies but the basic patterns will remain the same. There is a wealth of reference material available for such objects and it is essential to find inspiration but, at the same time don't be too ambitious and try to reproduce some of the complex designs you will find on historical armour. Instead, opt to reduce the design to a fairly simple pattern on the dome of the skullcap.

Add the shapes of the wings on the helmet. Notice how they are **17** hung on the original 'antennae' but curve behind them for greater visual effect. Erase some of your cloak and draw the basic shape of the beard and moustache in long flowing lines working outwards from the face and going in the same direction as the cloak.

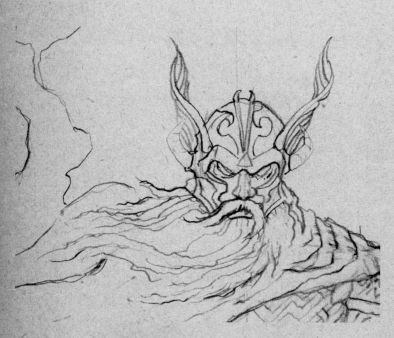

18 Now fill in the details of the face: the eyes should appear as two semicircles from beneath the brow of the helmet and the nose should be built from a basic triangle shape. Add more detail to the moustache and beard.

Add the spear at this stage, carried in the left hand. After about an **19** hour the final rough should look something like this. But don't despair if it takes you longer than this … if you put the hours in, you *will* get there.

Tightening up

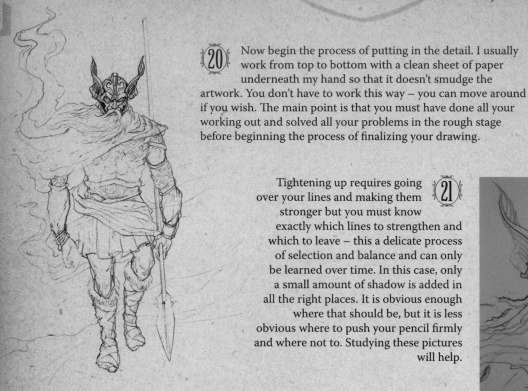

20 Now begin the process of putting in the detail. I usually work from top to bottom with a clean sheet of paper underneath my hand so that it doesn't smudge the artwork. You don't have to work this way – you can move around if you wish. The main point is that you must have done all your working out and solved all your problems in the rough stage before beginning the process of finalizing your drawing.

21 Tightening up requires going over your lines and making them stronger but you must know exactly which lines to strengthen and which to leave – this a delicate process of selection and balance and can only be learned over time. In this case, only a small amount of shadow is added in all the right places. It is obvious enough where that should be, but it is less obvious where to push your pencil firmly and where not to. Studying these pictures will help.

Beard

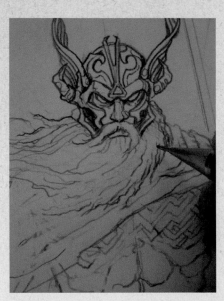

22 Use the erase-pencil-erase process (see page 80) to build up tone and depth in the drawing. Use your fine eraser to follow the lines of the beard. You will see that this eradicates many of the lines but they are still just visible.

23 Now go back in with the pencil working along the outer edge of the beard shape. Your new pencil lines should cut across the original outer edge of the beard, breaking up the line with shorter, flowing strands of hair.

24 After you have gone over the whole beard go back in with the eraser and select certain places that obviously stand out as areas that should be white, such as the line of the moustache. Use the eraser very lightly here, as if it were a brush, and using short, gentle strokes 'brush' away the pencil lines.

25 You can see how the mixture of eraser and pencil has resulted in a beard with more body than any amount of Viking-strength hair conditioner could provide.

As you work across your drawing you will need to add a variety of details and rely on a 'library' of different types of pencil marks. You will develop these marks with time and practice and will probably use them throughout your career. Apply some small 'flecks' on the underside of the lip of Odin's waist armour, and use various squiggles to suggest beaten metal. **26**

27 While it is important to do all your 'working out' at the rough stage, it is never too late to make major changes. It was at this relatively late stage that it became apparent that Odin's arms were too long and that he was starting to look like an orang-utan, so they had to be shortened.

28 A drawing like this requires very little shadow so build up your dark areas with a series of lines rather than heavy shadow. For the cloth on Odin's trousers draw a series of lines that follow the curve of his legs. This has the effect of gradually building up the shadow area under the kilt and also suggesting the rough weave of the cloth. Add further detail to the spear, curving your pencil strokes to create the rounded shape of the shaft.

Shadow

29 You can see here how shadow has been built up by successive layers of lines rather than the use of heavy pencilling. It is important to remember that, overall, you should use the pencil quite lightly and build up the dark areas by repeatedly going over the same lines and constantly sitting back to look at the drawing and make sure the overall tonal balance is consistent.

BACKGROUND

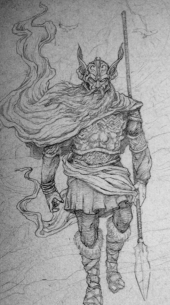

30 For the background, work with very light pencil lines. The snowy mists complement Odin's swirling cloaks and the mountain frames the spear. Odin is always pictured with his two ravens, Huggin and Munnin (meaning 'thought' and 'memory'), so add them now, turning on the winds in the near distance.

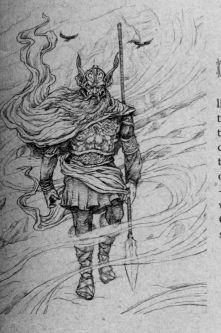

31 Now add some shadow to the background elements. Do it very lightly with soft strokes and try rendering all the lines in the same direction to ensure consistency. After working on the very soft shadow areas go over the mist with an eraser – you can see here how it works where it crosses over Odin's legs, with the legs still showing through slightly.

At this stage your image should be complete, **33** although you could scan it and experiment with subtly colourizing it in Photoshop. This has the effect of changing all the pencil lines to a single colour. Finally, try placing it on a sampled background of textured paper to give it an antiquated feel.

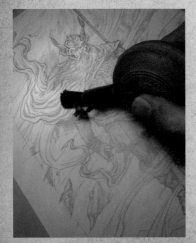

32 Throughout the process of drawing you can keep your artwork tidy by using one of these blowers, used in photo labs for keeping negatives clean. This stops eraser rubbings from smudging pencil lines. You could also work with a blank sheet of paper resting beneath your palm to prevent smudging.

Expedition's End

So, there you have it – your final image is complete and our expedition is over. Despite having written and illustrated five books on the subject, everything I could teach a prospective fantasy artist can be summed up as follows:

· Feed your imagination with a wide range of diverse research. Inspire yourself and share your knowledge with others so they will share their knowledge with you.

· Draw, paint and write – a lot. Repetition and practising will develop your instincts and strengthen your creative muscles.

· Don't aim for results – explore and experiment. Being playful, having fun and making mistakes is the best way to learn.

BIOGRAPHY

Finlay Cowan is known for his design work with Storm Thorgerson producing album sleeves, films and advertising for Pink Floyd, Muse, Audioslave and many others. He designed Pink Floyd's world famous 'Back Catalogue' poster and numerous other iconic images in art and advertising. His company, Endless Design Ltd, advises companies on creative direction and produces global graphics, advertising, branding and marketing campaigns and strategy. Finlay also lectures on creativity to companies and educational institutions and is creative director for the Luxury Marketing Council Europe. He works as a concept designer in the film industry and has developed and written fiction and non-fiction for the BBC and other production companies worldwide.
www.finlaycowan.co.uk

Author photo by Mark Whitfield
www.markwhitfieldphotography.com

ACKNOWLEDGMENTS

Finlay's thanks go to: Chiara Giulianini, my assistant and colourist for her effort, patience and dedication.
For life support: Janette Swift and Tyler Swift Cowan, friend and mentor Bill Bachle, Monika Kurtova and Tracey Howes. Special thanks to editor Lin Clements for her invaluable work on the manuscript.
For input and inspiration: Neil and Geri, Mum Cowan, John Swerdlow and Emily Garner, Marlene Stewart, Adele Nozedar and Adam Fuest, Adrian and Natasha Seery and family, Vicki Forrest and Stuart Smith, Marcia Schofeld, Anne Mensah, Lou Smith and Lorraine Liyanage, James Rands, Richard Hooper, Tracey Millar, Storm Thorgerson, Rupert Truman, Peter Curzon, Dan Abbott, Trisha Biggar, Roxanna Albeck, Alma Fridell, Alice White, Asa Haselblad, Annemarie Moyles, Estrella Santana, Mireia Prim, Jens Gruneberger and Charlie Damgaard.
Models: Georgina Parkes, Masha, Lili Moria.
And of course: Bob Hobbs, Jeremy Beswick, Ana Genes, Claudia Drake, Julia Jeffrey, and everyone else I met on the internet who inspired me with their art.

CHIARA GIULIANINI

Chiara graduated from Camberwell College of Arts, London, with a degree in conservation of organic materials and went on to further specialization in the restoration of paper-based art objects. After moving back to her home town of Milan and working as a freelance restorer for two years, she took up the offer to work for her friend Finlay Cowan and acquire skills and knowledge necessary for working in the film industry. Chiara also works as a costume designer and set designer for theatre.

Chiara's thanks go to: my family for their support. Also to Finlay Cowan and Janette Swift for their trust and for helping me open doors

Nature spirit witnessed by the author in Le Marche, Italy August 2008.

Muse goddess witnessed by the author in Wales in 1996, possibly in a dream. She had the most benign smile and carried an eagle on her shoulder.

Nature spirits seen inhabiting the trees in Le Marche, Italy, August 2008.

INDEX